HEADIN' FOR
BETTER TIMES

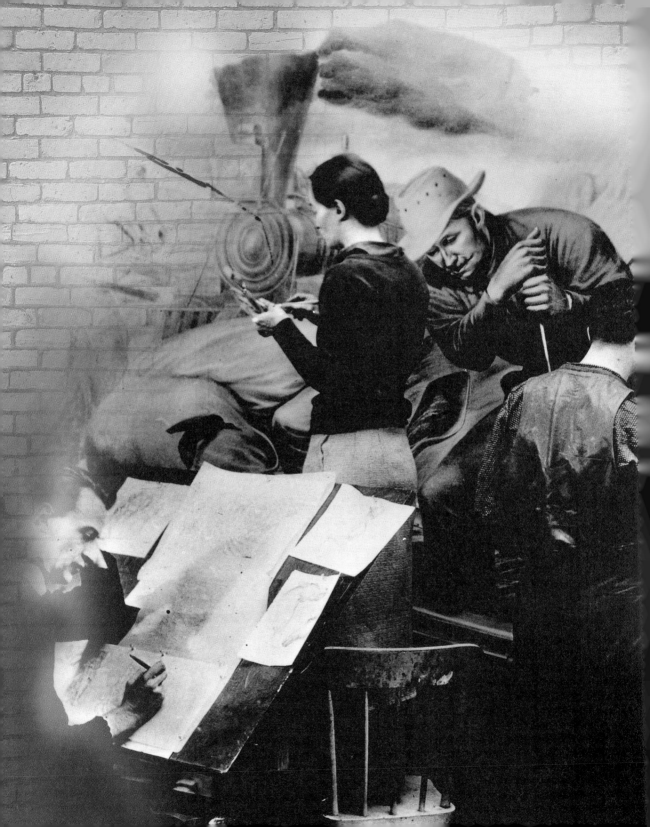

THE ARTS OF THE GREAT DEPRESSION

HEADIN' FOR BETTER TIMES

Duane Damon

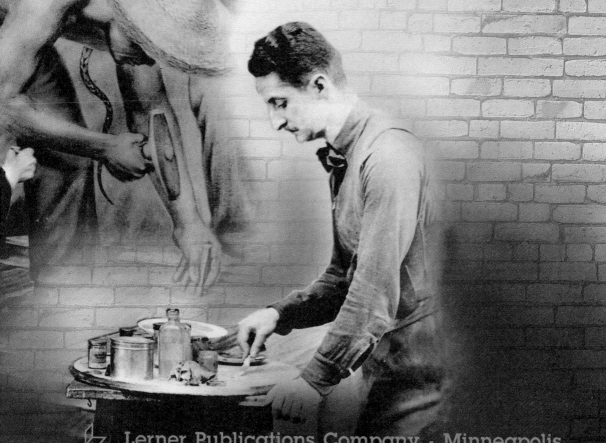

Lerner Publications Company · Minneapolis

*For my father, John M. Damon, and in memory of my
mother, Ruth Eloise Price Damon, who first told me stories
of the Great Depression*

Special thanks to the following for their contributions to this book: Susanne
Hicks, Sandy Frye, and Terry Cone; and former WPA artists James Lechay
and Lillian Orlowsky

Lerner Publications Company
A division of Lerner Publishing Group
241 First Avenue North
Minneapolis, MN 55401 U.S.A.

Website address: www.lernerbooks.com

Library of Congress Cataloging-in-Publication Data

Damon, Duane.
 Headin' for better times : the arts of the great depression / by Duane
Damon.
 p. cm. — (People's history)
 Includes bibliographical reference and index.
 ISBN 0-8225-1741-8 (lib. bdg. : alk. paper)
 1. Arts, American. 2. Arts, Modern—20th century—United States.
 3. Arts—Psychological aspects. [1. United States—Social life and
 customs—1918–1945.] I. Title. II. Series.
 NX504. A1 D36 2002
 700'.973'09043—dc21 00-012497

Manufactured in the United States of America
1 2 3 4 5 6 – JR – 07 06 05 04 03 02

Contents

OLD MAN DEPRESSION

Our American experiment...
has come nearer to the abolition
of poverty... than humanity has
ever reached before.
> —Herbert Hoover, in a
> campaign speech,
> October 22, 1928

When president-elect Herbert Hoover was inaugurated in early 1929, he made a confident prediction. "I have no fears for the future of our country," he proclaimed. "It is bright with hope." Yet in less than a year, many American artists (photographers, popular songwriters, painters, and many others) were depicting a nation in desperate turmoil. Poet Geneviève Taggard expressed the situation in her poem "Creative Effort":

> Have you a theme?
> Starvation.
> In this country?
> Yes, starvation. In this country.
> Do you mean, nothing to eat?
> Yes, to begin with.
> Unpleasant theme and very hard to handle.

How did American artists find themselves giving voice to such despair?

When Hoover was inaugurated, few citizens would have argued with his optimistic assessment of the nation. The "Roaring Twenties" seemed to have brought little but prosperity. The United States had become a world power during the war that had ended in 1918—World War I. Tooling up to produce war materials for itself and its allies had transformed U.S. industry from a scrappy youngster into a strapping adult. Factories ran at full tilt. People had jobs and comfortable homes. "The prosperity band wagon rolled along with throttle wide open and sirens blaring," observed historian Frederick Lewis Allen.

Throughout the decade, businesses merged with other businesses. These larger businesses had the clout to keep wages low. Consequently, ordinary people such as store clerks, office workers, mechanics, and others received only a small fraction of the nation's wealth. In contrast, a scant one-twentieth of the population enjoyed a hefty one-third of all personal income.

Meanwhile, businesses also raised prices. Most employees found themselves unable to afford the products they helped to make. In short, the United States was producing more than it could consume. The economy began spinning out of control.

Nowhere did it spin faster than on Wall Street, home of the country's stock exchange. Lured by the prospect of easy money in the "boom" economy, new investors rushed to buy shares of AT&T, U.S. Steel, and other corporations. To attract even more buyers, stockbrokers began selling stocks "on margin." This scheme enabled investors to buy stocks on credit. Offered this temptation, investors went wild. So did prices. In the last years of the 1920s, some stock prices doubled, tripled, or even quintupled. Banks ran low on money for credit, further weakening the stock market's financial base. Something had to give.

On October 24, 1929— "Black Thursday"—the prices of stocks took a nosedive. Nearly thirteen million shares were sold at losses of at least eight billion dollars. A few days later, a second collapse staggered the market. This time—Tuesday, October 29—sixteen million shares

changed hands. Two weeks later, thirty billion dollars in investors' profits were only a memory. In a sickening crash of prices, promises, and dreams, the Great Depression was on.

"NO HOME, NO WORK, NO MONEY"

Within weeks, millions of citizens began feeling the terrible weight of the crash. Scores of banks that had invested their customers' money in the stock market were forced to close. Countless lower- and middle-class people who did business with those banks saw their hard-earned savings go up in smoke. In 1930 alone, more than thirteen hundred banks shut their doors. Twenty-six thousand businesses folded that year.

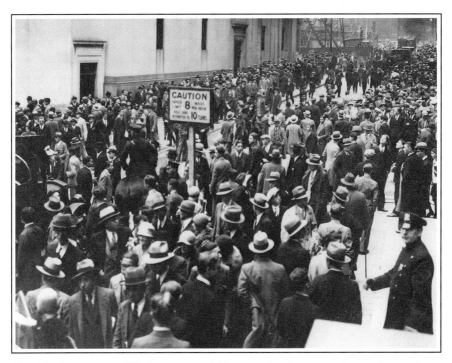

Panicked investors fill the streets of New York City after the stock market crash of October 1929.

Sales of goods fell dramatically. Merchants ordered less new merchandise for stocking their stores. Factories cut back on the goods they produced. Many workers took cuts in pay, and many were fired. By the end of 1931, more than eight million people had lost their jobs.

Workers in this era had little protection against such losses. Labor organizer Anne Timpson described the conditions:

> If a worker lost his or her job, there was no unemployment insurance. If they were too old to work, there was no social security. If they or any of their family became ill, there was no medical assistance. If they couldn't pay the rent, they were evicted from their homes, their belongings dumped on the sidewalk, and the family left to get along as best it could.

Unemployed workers crowded into employment offices to ask for help in getting a job. People who had been lawyers or stockbrokers weeks earlier stood on street corners selling apples for a nickel. Charities struggled to provide food and shelter for the needy. Hungry men and women waited docilely in lines that stretched for blocks, just to get a serving of bread. Children shared the deprivations. "My children have not got no shoes and clothing to go to school with," wrote a West Virginia man. "And we haven't got enough bed clothes to keep us warm."

Many people couldn't pay their rent or keep up the mortgage payments on their houses. "My father hasn't worked in 5 months," wrote a twelve-year-old boy from Chicago, Illinois. "We haven't paid 4 months rent. Everyday the landlord rings the door bell, we don't open the door for him. We are afraid we'll be put out." And a parent from Pennsylvania wrote, "No home, no work, no money. We cannot go along this way."

Thousands lost their homes. A 1931 census taken in New York City showed fifteen thousand displaced men wandering that city's streets. Homeless people slept in alleys and on park benches. They built crude shacks of tar paper, scraps of lumber, and crates near city dumps and along railroad tracks. These shantytowns were called "Hoovervilles," after the nation's president.

To most Americans, Herbert Hoover's inaugural promise of a future "bright with hope" seemed little more than self-delusion. In a musical stage show called *Face the Music,* composer Irving Berlin's song "Let's Have Another Cup O' Coffee" satirized Hoover's blind optimism:

> Just around the corner,
> There's a rainbow in the sky,
> So let's have another cup o' coffee,
> And let's have another piece o' pie.

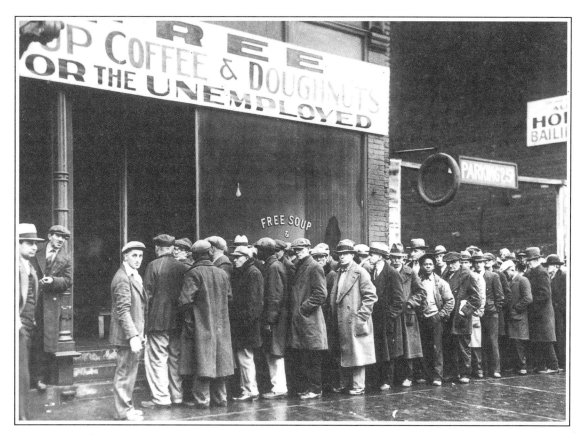

Jobless people wait in line for a handout of coffee and doughnuts. "Bread lines" like this one were common during the depression.

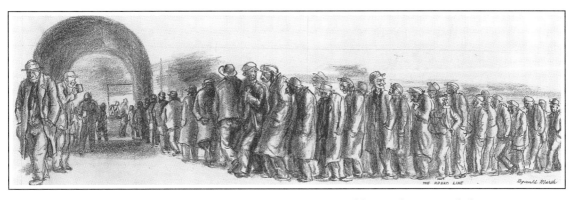

In this drawing, **The Bread Line** *(1929), Reginald Marsh captured the despair and humiliation felt by many who had to rely on bread lines.*

Mister Herbert Hoover
Says that now's the time to buy,
So let's have another cup o' coffee,
And let's have another piece o' pie.

Not everyone experienced hardship. But the sight of hordes of jobless people made some wealthy people uneasy. Desperate people could too easily become enraged. In 1931 banking millionaire J. P. Morgan questioned whether he ought to use his yacht. "It seems very unwise to let the *Corsair* come out this summer," he commented to a friend. "There are so many suffering from lack of work . . . that it is both wiser and kinder not to flaunt such luxuriant amusement in the face of the public."

ARTISTS ON THE ROPES

One movie of this era opened with a scene showing a new Broadway show in rehearsal. The smiling chorus girls in the scene wear costumes that glitter with make-believe money. They have coins for earrings, coins for necklaces, and coins on their caps. Giant replicas of silver dollars tower over them. At center stage, actress Ginger Rogers launches into a breezy song:

We're in the money,
The sky is sunny.
Old Man Depression, you are through,
You done us wrong.

Suddenly a team of sheriff's deputies swarms onto the stage. Seizing props, they announce that the production owes too much money to creditors and is being shut down. "This is the fourth show in two months that I've been in and out of," complains one chorus girl. "They close before they open," agrees another. Ginger Rogers supplies the reason: "The Depression, dearie."

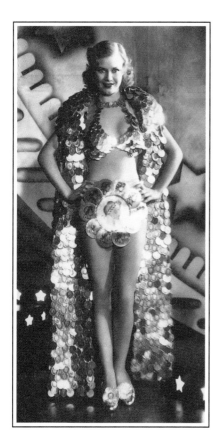

Actress Ginger Rogers wears a costume glittering with gold coins for the hit movie **Gold Diggers of 1933.** *Moviemakers used glitter and glamor such as this to transport depression-weary audiences into the imaginary world of film.*

This scene from the motion picture *Gold Diggers of 1933* was replayed in real life again and again. Like the fictional Broadway actors, thousands of real-life actors, stagehands, and technicians lost their livelihoods during the depression. Sometimes they fought back. For example, actors in Abingdon, Virginia, opened the Barter Theater, where customers paid admission in eggs, milk, meats, flour, vegetables, and other necessities.

The movie industry suffered less than live theater. The first "talking pictures" had arrived in 1927, and Americans were still enthralled by this new medium. Besides, a ticket to a live play cost more than a dollar, while a movie cost only a quarter.

But even Hollywood felt pinched by the loss of some of its paying public. Early in the depression, all studio personnel at Warner Brothers took a 50 percent salary cut. As the owners of movie houses struggled to fill seats, some slashed admission to a dime or even a nickel. Some offered special promotions as well. June Lassack, daughter of a movie house owner during the 1930s, recalled how her father boosted business:

> Every night was "Dish Night," when a piece of pink dinnerware was given away with every admission. Now those dishes are known as Depression glass. . . . Dad eventually replaced "Dish Night" with something he called "Payday Night." Everyone who bought a ticket got to select a manila envelope containing money. Most contained pennies, but others held nickels, dimes, quarters, and even a few one- and five-dollar bills.

Not just actors but all kinds of artists, from comedians to sculptors to novelists, were hard hit by the depression. For example, musicians got fired when restaurants and hotels could no longer afford the luxury of orchestras. Opera companies canceled entire seasons. Schools laid off the music teachers for their bands and choruses. Tens of thousands of instrumentalists, singers, and music educators were out of jobs.

Like people working outside the arts, artists keenly felt the anguish brought on by a shattered economy. "The Depression . . . had made the whole world about me one of torment, hunger, and rebellion," wrote New York painter Seymour Fogel. "Everyone seemed to be caught up in it. Painters, sculptors, poets, writers, dramatists were as one in crying out in protest."

To make matters worse, Mother Nature also ravaged parts of the country during the 1930s. In some places, floods destroyed homes and businesses. The Great Plains suffered a prolonged drought that took a terrible toll on farmers.

Artists portrayed all of this. Writers had "the job of seeing the mess in which the plain people had been trapped," according to author Tess Slesinger. By describing the "life of the moment" in the real world, rather than depicting only things of beauty, writers could help people "cease to think of themselves as helpless victims and alone."

Many artists became disillusioned with capitalism—the U.S. economic system—and turned to left-wing politics. A few even joined the Communist Party/USA. These artists used their art to promote the causes they supported, such as workers fighting for better wages.

Painter Louis Guglielmi was one of many who believed artists must work actively for a better world. "The artist found himself helplessly part of a devastated world," he wrote. "Faced with the terrors of the realities of the day, he could no longer justify . . . the role of spectator." One of Guglielmi's paintings, *The Relief Blues,* shows an urban family in their apartment. At a table sits a federal worker ready to sign them up for relief—financial help from the government. As the husband and wife answer the federal worker's questions, their faces are strained and embarrassed. The process of applying for relief is clearly painful. Unlike Guglielmi, who could not accept "the role of spectator," the couple's unconcerned teenage daughter sits nearby, casually putting on her lipstick.

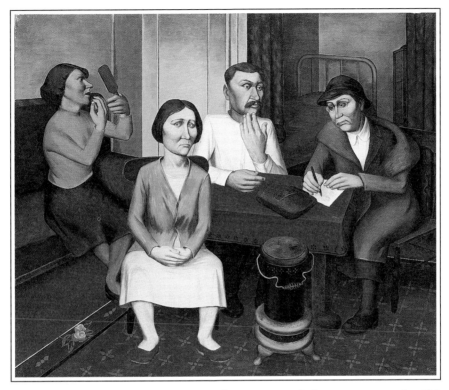

The Relief Blues *(1938), a painting by Louis Guglielmi, portrays a family's painful decision to accept financial help from the federal government.*

HAPPY DAYS WILL COME AGAIN

At the same time, artists certainly did not limit themselves to showing economic burdens. Many songwriters, for example, joined other Americans who managed to hold on to hope. The 1931 recording of "Headin' for Better Times" made a hit with its upbeat lyrics. Performed by Ted Lewis and his orchestra, the song declared that Americans were "on track" to a renewed prosperity:

> Don't pack a trunk of junk filled with yesterdays,
> Tomorrow will only bring sunshine.
> As we go from state to state,

We'll be shouting "Things are great!"
On the choo-choo choo-choo headin' for better times!

Songs like this one, insisting that the future would be rosy, were like a tonic to a depression-weary public. When Franklin Delano Roosevelt (FDR) ran for president in 1932, he chose another popular upbeat tune, "Happy Days Are Here Again," as his campaign song:

Happy days are here again!
The skies above are clear again!
Let's sing a song of cheer again.
Happy days–are–here–a–gain!

The song must have been a good choice. The 1932 election threw Herbert Hoover out of the White House and swept Roosevelt in. The jaunty New York-born Democrat brought the nation new hope and a "New Deal"—his program for helping the nation recover from the depression.

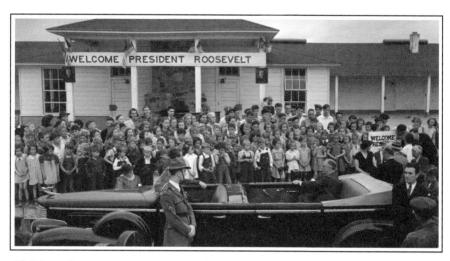

Children from Pine Mountain Valley Homestead School in Warm Springs, California, greet President Franklin Roosevelt in 1938. They are singing "Happy Days Are Here Again," a song he had helped make famous.

The New Deal began immediately after FDR was inaugurated in March 1933. First, he ordered a "bank holiday" when banks would be closed. This would buy time to reorganize the ailing banking system. Next, he and Congress created a string of new laws and agencies to set the nation on the road to recovery. Some of them gave people "direct relief." They doled out money or provided food, housing, and other necessities. Other programs provided "work relief." Work-relief programs created jobs. FDR believed people would rather earn a living than accept a handout. Work relief helped people salvage their self-esteem.

The Public Works Administration (PWA) was a work-relief program. It hired people to build dams, military airports, civic buildings, and bridges all across the country. The Civilian Conservation Corps (CCC) put men and boys to work paving roads, constructing parks, and planting trees. The Resettlement Administration (RA) helped farmers relocate to more fertile land. (In 1937, this agency was replaced by the Farm Security Administration, or FSA.)

Members of Congress passed Roosevelt's New Deal legislation with unprecedented speed. While some people criticized handouts and "make-work" programs, most ordinary citizens eagerly followed Roosevelt's leadership. Will Rogers, the most beloved humorist of the day, quipped, "The whole country is with him [FDR]. If he burned down the Capitol, we would cheer and say, 'Well, we at least got a fire started anyhow.'"

Like Will Rogers, other artists also found whimsy and humor around them. Joy, romance, tenderness, exuberance, a love of adventure and fantasy and suspense—all of these take their place alongside grief and worry in the arts of the Great Depression. Artists gave genuine and moving language, image, and song to a wide array of human experiences, producing a renaissance that is perhaps unparalleled in American history. In many ways, the arts of the Great Depression—in all their rich variety—expressed the soul of a generation and helped to shape the nation's view of itself for decades to come.

AMERICAN MEANINGS

*For the first time in history,
American artists as a group . . .
have turned their eyes on
themselves and their own country.*
 —a Federal Art Project state
 director, 1938

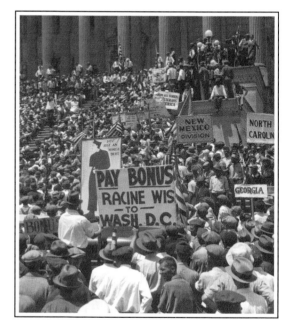

The arts of the Great Depression reflected many aspects of American life. Although the stock market crash and the hardships it brought influenced much of the era's artistic output, artists were also influenced by an array of other events, ideas, and personalities around them. In part, the arts reflected the nation's recent past. Nine million men, including many Americans, had died in the trench warfare of World War I. For many people, memories of the "Great War" were too terrible to ignore, too vivid to forget.

But the same men who had done the fighting were among the Americans passed over by the prosperity of the 1920s. In many cases, returning "doughboys" found themselves without jobs or homes. In 1924 Congress had authorized a deferred cash bonus for every veteran. (It would not be paid until 1945.) In the spring of

1932, veterans desperate for money appealed to President Hoover for immediate payment. He denied the request. To press the point, an estimated twenty thousand veterans from all across the country marched on Washington, D.C.

The "bonus marchers," as they were called, set up camp in the city's streets and parks and even on the grounds of the Capitol. For weeks the government took no action. By the end of July, however, with bonus marchers still camping nearby, Hoover grew impatient. He sent troops under General Douglas MacArthur to remove the bonus marchers from the city. When some marchers resisted, the troops opened fire. Two veterans were fatally wounded. The nation was outraged.

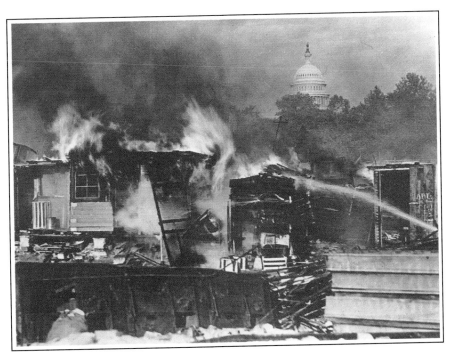

In 1932 federal troops sent by President Herbert Hoover clashed with bonus marchers, setting fire to shacks in their temporary camp in Washington, D.C. The U. S. Capitol towers in the background.

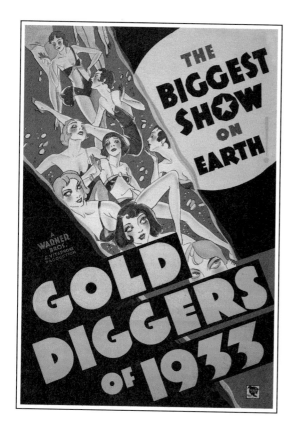

Although this poster reflects the glamour of Gold Diggers of 1933, *the movie also served as a commentary on the "forgotten" veterans of World War I.*

Gold Diggers of 1933 was, in part, Hollywood's response to this incident. In one scene, actress Joan Blondell leans against a lamppost on a dim city street. In song, she pleads for justice for the forgotten veteran:

> Remember my Forgotten Man,
> You put a rifle in his hand.
> You sent him far away,
> You shouted "Hip hooray!"
> But look at him today!

Then the scene shifts, and the street corner disappears. Uniformed men, marching confidently off to war, appear. The scene changes again, to show bloodied soldiers trudging through dark rain after a battle.

Next the same men appear waiting forlornly in a bread line. A final scene dramatizes how much ordinary people identified with the plight of the veterans. Blondell and a crowd of citizens belt out the last verse:

Forgetting him, you see
Means you're forgetting me
Like my Forgotten Man!

"I BUILT THE RAILROADS"

The power of popular music to express the moods of the depression was demonstrated again and again. "Brother, Can You Spare a Dime?" became the signature song of the era after popular crooner Rudy Vallee sang it on a recording in 1932. The song's brooding lyrics, written by E. Y. Harburg, recalled both World War I and the boom days of the 1920s gone sour. Everyone—both civilians and veterans—had helped to build the United States into a world power. As Harburg explained in an interview with author Studs Terkel, "This is the man who says: 'I built the railroads. I built that tower. I fought your wars. . . . I made an investment in this country. Where the h - - - are my dividends?'" As his song put it:

They used to tell me I was building a dream
And so I followed the mob.
When there was earth to plow or guns to bear
I was always there, right on the job.

They used to tell me I was building a dream
With peace and glory ahead.
Why should I be standing in line
Just waiting for bread?

Once I built a railroad, made it run,
Made it race against time.
Once I built a railroad, now it's done,
Brother, can you spare a dime?

John Dos Passos, a prominent author during the depression, captured the spirit of the nation by incorporating newspaper headlines and other real-world details into his innovative prose.

THE U.S.A. OF JOHN DOS PASSOS

In the wake of World War I came a wave of writers who tried to express the individual's struggle to understand the war and the decade that followed it. Often their work was branded by disillusionment. The war had accomplished so little at so high a price. F. Scott Fitzgerald and Ernest Hemingway are two well-known authors among this generation of writers.

The crash of 1929 brought its own disillusionment. For the first time, many Americans questioned whether capitalism could work. The Communist Party/USA actively opposed capitalism and especially big business. During the presidential election campaign of 1932, writers Sherwood Anderson, Theodore Dreiser, and John Dos Passos supported the Communist Party ticket.

Born into an affluent family in Chicago, Dos Passos grew up to become a journalist who wrote for communist periodicals such as the *The Daily Worker*. As a nonfiction magazine writer, he developed a mass of factual detail that he later included in a series of three novels: *The 42nd Parallel, 1919,* and *The Big Money* (published in 1930, 1932, and 1936, respectively). This massive trilogy, which he called U.S.A., was essentially

an artist's conception of the history of the United States after 1900.

Dos Passos gave readers the feeling that they were reading about actual news events by including headlines (such as "Vice President Empties a Bank") and written versions of "newsreels" (the news shown in movie theaters in the days before TV). He also used popular songs and biographies of public figures. Headlines such as "Mob Lynches after Prayer" dramatized the problem of lynching— the execution of an African American by a mob. Others spotlighted the struggle of American workers to band together in unions to fight for better wages, hours, and working conditions.

As he combined facts in new ways, Dos Passos prompted readers to think about them in new ways. By showing readers the larger meaning of the "hodge-podge of consciousness," he could help the nation rise above its thoughtless ways. His novels seemed to put the nation under a magnifying glass. Americans had never read anything like them before.

In the opening of *The 42nd Parallel,* Dos Passos suggested that a young man felt a connection to others through their art—the stories and jokes and tall tales they told:

> It was not in the long walks through jostling crowds at night that he was less alone . . . or in the empty reek of Washington City hot boyhood summer nights . . . but in his mother's words telling about longago, in his father's telling about when I was a boy, in . . . the tall tales the doughboys told after taps; it was the speech that clung to the ears, the link that tingled in the blood: U.S.A.

Writers were not the only creative workers sharing new images of the nation. Visual artists had powerful stories of their own to tell.

THE AMERICAN SCENE

It's a scene out of a midwestern nightmare. A young Kansas family scrambles out of their farmhouse toward the shelter of a nearby storm cellar. An ominous, funnel-shaped tornado spins ghostlike in the

background. The anxious mother glances apprehensively over her shoulder at the children who hurry along behind her. Tall and muscular, the father appears ready to shield his loved ones from the fast-approaching danger. An onlooker might wonder for a moment whether the family will make it to safety before the funnel hits.

Such was the drama of *Tornado over Kansas*, an oil painting created in 1930 by Kansas artist John Steuart Curry. Into its compact

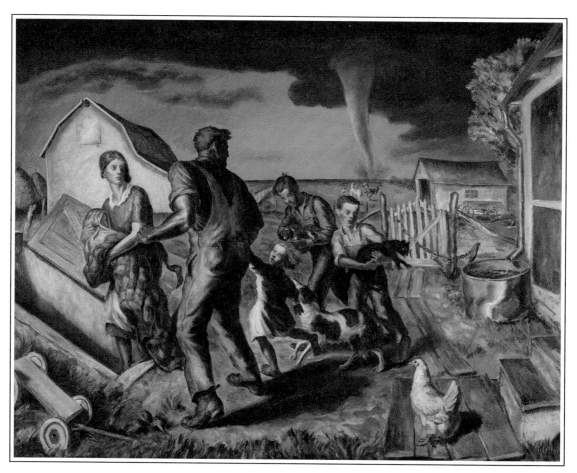

In **Tornado over Kansas** *(1930), John Steuart Curry illustrated the struggle to survive nature's fury.*

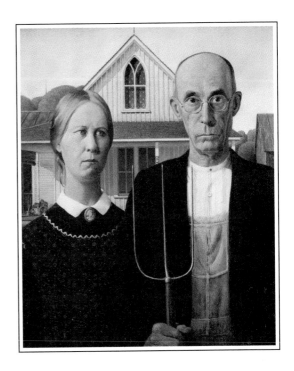

American Gothic (1930) by Grant Wood became one of the best-known paintings of the depression. Wood often critiqued the past, saying American culture could not thrive "until the whole colonial idea is put in the museum where it belongs."

design Curry packed a flurry of physical action that conveys both danger and the determination to survive.

That same year, an Iowa artist received a good deal of attention for a portrait that became the most popular painting of the 1930s. It depicts a staid midwestern farm couple. The daughter stands rigidly beside her father, who grips a pitchfork. Grant Wood did not intend for the pair (which he modeled on his sister and his dentist) to offend anyone. Many Iowans took offense anyway, however, complaining that Wood's picture mocked their simple virtues. Nevertheless, when the Chicago Art Institute of Chicago, Illinois, showed *American Gothic,* viewers and critics there quickly praised it. Decades later, many Americans can still bring this portrait readily to mind. In fact, it has been published so often that it has almost become a cliché.

Around the same time, Thomas Hart Benton of Missouri was creating nine mural panels for the New School of Social Research in New York

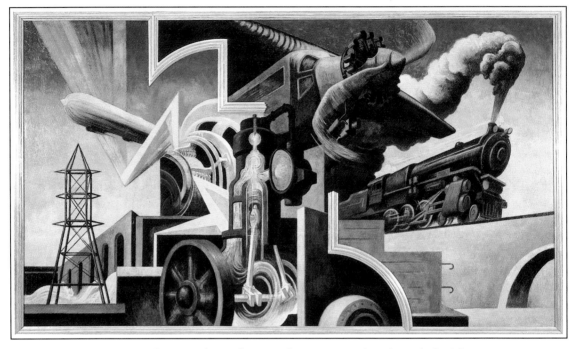

Instruments of Power *from the mural* **America Today** *(1930), by Thomas Hart Benton, evokes American vitality through symbols of industry.*

City's Greenwich Village. He called his effort *America Today*. In it, lumberjacks, welders, prizefighters, steelworkers, cowhands, surveyors, and street preachers chopped, welded, punched, herded, measured, and preached on constructions sites, prairies, and street corners. The work practically vibrated with the energy of a growing nation.

Curry, Wood, and Benton were pioneers in the most important art movement of the 1930s: the American Scene. Its paintings showed U.S. cities and farms, plains and mountains, people and industries. The movement signaled a significant shift. American artists no longer looked to Europe for their subjects, as they once had. They found more than enough inspiration close around them. As Benton put it, he sought to "make pictures . . . which would carry unmistakable American meanings for Americans."

AN AMERICAN SOUND: GERSHWIN

As the nation began to leave the wounds of World War I behind, the urge to develop uniquely American art was expressed again and again. One notable American original was composer George Gershwin.

Born to Russian Jewish immigrants in 1898, Gershwin was fifteen when he got a job playing the piano in a music publishing house in Tin Pan Alley, a music-producing district in New York City. He was hired to demonstrate new compositions being released by the publisher. But before long, Gershwin was composing his own music—with a string of Broadway scores and concert pieces such as *Rhapsody in Blue.* Gershwin's music was influenced by Jewish musical traditions and by black folk music, jazz, and the blues. The result was a unique sound that was unmistakably American.

In 1931 Gershwin created the musical score for a Broadway show called *Of Thee I Sing.* His brother Ira provided the lyrics for the songs. The show's plot followed the outrageous scheme of some political bosses who wanted to get their hand-picked candidate elected president. Many of the show's tunes, such as "Love Is Sweeping the Country," became widely popular. Delighted audiences made *Of Thee I Sing* the third-longest-running musical of the 1930s.

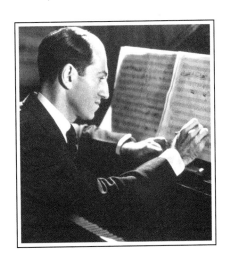

George Gershwin created uniquely American music by drawing on spirituals, jazz, and other musical traditions. Here he works on the score for his beloved opera **Porgy and Bess** *in 1935.*

UNCLE SAM AND THE ARTS

In the Depression . . . art for art's sake is a tattered banner which has been blown down by the wind.
— Holger Cahill, 1934, before becoming Federal Art Project director

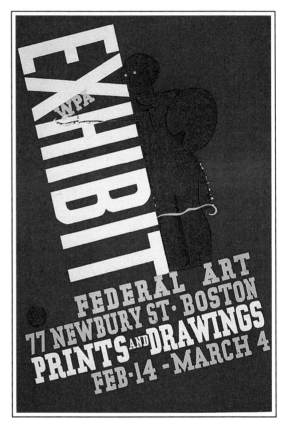

As Franklin Roosevelt's New Deal policies grappled with the cruelties of the 1930s, a new idea slowly took hold. The first work-relief programs employed carpenters, secretaries, and others—but not artists. The arts were considered luxuries of the rich. Employing artists did nothing for the general public.

Hard times brought change, however. The New Deal's sweeping reforms included the Works Progress Administration (WPA). FDR placed Harry Hopkins at its head. Both FDR and Hopkins were

only too aware that unemployment had hit artists just as it had affected others. In their view, artists were entitled to work relief through WPA, just as others were.

ART FOR THE MILLIONS

In 1935, at their urging, Congress gave the WPA twenty-seven million dollars to employ jobless artists. This mission stood in startling contrast to a Section of Fine Arts that had been added to the U.S. Department of the Treasury earlier. The section commissioned artwork for federal buildings. But it set such high standards that few artists could hit the mark. As the section's head, Edward Bruce, said, "There are not enough artists on relief to do our job and maintain the quality for which we stand." At its peak, the section employed just 356 artists. In contrast, the WPA required that 90 percent of its artists be drawn from the list of people receiving direct relief. Within a year, it employed forty thousand artists in projects throughout the United States. The WPA arts program was called Federal Project Number One, or Federal One. It was organized into the Federal Art Project (FAP), the Federal Theater Project (FTP), the Federal Music Project (FMP), and the Federal Writers Project (FWP). (A fifth Federal One agency was the Historical Records Survey.)

Holger Cahill, Federal Art Project director, noted that American artists had largely fled to a few large cities to find work. Since the WPA created jobs in small towns as well as in cities, artists could work in their own hometowns.

In addition, Cahill believed art should be accessible to everyone. To provide what came to be called "art for the millions," his agency sponsored traveling art exhibits, concerts in small towns, murals in public buildings, and many other projects that reached into every corner of the nation. Cahill pointed out, "Such a simple matter as finding employment for the artist in his hometown has been of the greatest importance. . . . It has brought the artist closer to the interests of a public which need him."

The WPA projects also sought to preserve minority cultures. For example, the Federal Theater Project sponsored plays performed in French, German, Italian, Spanish, and Yiddish. It established black theater companies in a dozen cities around the nation—all places where white performers were much more likely than black performers to find work. All-black productions often explored themes related to the experiences of African Americans.

Not everyone approved of Federal One. By 1935 critics in Congress and the press had grown steadily louder in their opposition to any kind of work relief. "Make-work" projects for artists seemed even more extravagant. "The average voter does not yet appreciate the

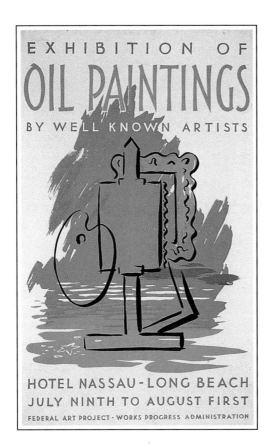

The traveling exhibits of the WPA, such as the art show advertised here, brought art to the millions.

need of encouraging art, music, and literature," admitted President Roosevelt. Not every politician did, either. "Culture?" growled one congressman. "What the h - - - ? Let 'em have a pick and shovel!"

Even some supporters of the arts took a cautious view. WPA artists were generally promised a wide range of freedom in their work. But some believed that if the federal government was paying artists' wages, it would inevitably try to control—censor—their work.

Yet Roosevelt and Hopkins remained convinced that the value of Federal One lay far beyond the immediate employment of artists. As fledgling writer Milton Meltzer put it, "In the middle of the Great Depression, we were beginning to learn something that we should have known long ago: Art was a necessity, something everybody's spirit thirsted for."

A MAN-YEAR ALLOTMENT

Meltzer was twenty-one and a budding writer when he dropped out of college and moved into a shabby brownstone in New York City. Like eight million other Americans, Meltzer had no job and no prospects for one. He applied for assistance at the local relief bureau and got a meager $5.50 a week ($286 over a year's time). "Dinner was a cheese sandwich and a cup of coffee," he recalled later. "Price—$.20. When rain or snow began squishing up through the holes in my shoes, I couldn't afford to repair them. My brother showed me how to take the pulpy separators out of egg cartons and stuff them into my shoes for protection."

For a young man with talent and a nearly complete college education, Meltzer's future looked bleak. Then, he related, "a few months later my luck changed." He snared a job in the press department of the Federal Theater Project. His job was to write press releases describing the project to schoolchildren.

Landing a Federal One position was not child's play. Artists had to prove to a relief agency that they were unemployed. As Meltzer recalled:

> In New York City, where I went on relief, the Home Relief
> Bureau put applicants through a stiff investigation. Did I
> have any property—a home, car, oil well, gold mine, shoe
> store, stocks, bonds? . . . Did I have money stashed in my
> mattress or in a savings account? Did I have insurance that
> could be cashed in? The relief investigator asked a million
> questions and took my word for nothing.

Once applicants proved they were both jobless and bona fide
artists, they could be hired. Meltzer's annual salary, or "man-year al-
lotment," was around $1,200—a big improvement over his relief
payment. This modest beginning led Meltzer to a distinguished writ-
ing career.

WPA artists often found themselves working with other artists.
The benefits of working with others who shared a passion for art
were obvious to Lillian Orlowsky, a muralist. She recalled, "Working
with and around your peers was stimulating. There was an economic
and political awareness. It changed my whole creative thinking."

As Federal One got under way, onlookers quickly saw that the
artworks created varied in quality. After seeing some murals, FDR
commented, "Some of it [is] good, some of it not so good. But all
of it [is] native, human, eager, and alive." As he put it, the artists
"painted about things that they know and look at often and have
touched and loved."

PAINTINGS, PEDESTALS, AND POSTERS

The FAP employed five thousand artists—painters, muralists, sculptors,
graphic artists, and others—in its first year. One hungry painter, James
Lechay, was grateful for the help from Uncle Sam. "We were paid
$23.86 a week," he remembered. "It enabled me to keep working on
my painting. This was a great luxury for us."

Over a period of eight years, FAP painters produced one hundred
thousand paintings in oil, pastel, and watercolor. James Lechay, Louis
Guglielmi, and the Soyer brothers (Isaac, Moses, and Raphael Soyer)

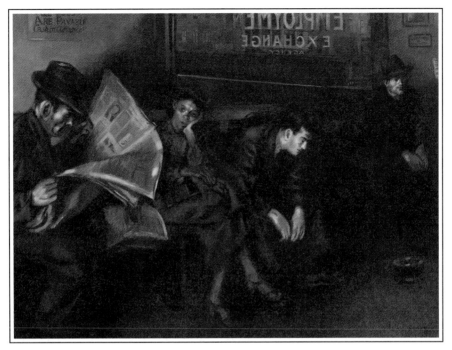

The muted colors of* Employment Agency *(1937) by Isaac Soyer express the grim realities of unemployment.

were just a few of the nine hundred FAP painters. Their canvases often revealed stark truths about the hardships of the depression. For example, Isaac Soyer's painting *Employment Agency* is almost a visual version of "Brother, Can You Spare a Dime?" It portrays a small group of idle folk as they sit in the waiting room of a government employment office. The artist's use of muted brown and gray lends a subdued mood to the scene. One man reads a newspaper to distract himself from his troubles. The drawn faces of the people at the right reveal an inner battle against despair.

At its peak, the FAP had five hundred sculptors on its payroll. They turned out close to eighteen thousand pieces of sculpture. More than twenty states furnished sculptors with workshop areas, materials, and storage space. Each artist was required to work fifteen hours per

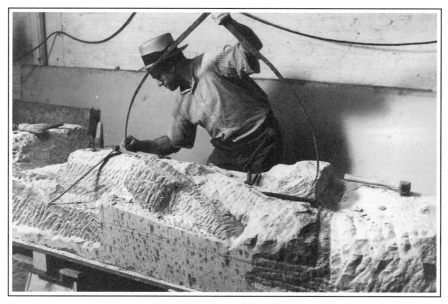

A FAP stone carver at work in a New York City studio

week, but many worked much more. "[The sculptor] was being paid a regular weekly wage to work in a studio as a freely creative artist," sculptor Robert Cronbach reported. "It was an unequaled opportunity . . . to advance the quality of his art."

Two types of sculpture were turned out by FAP sculptors. The first was "pedestal" sculpture. These were freestanding pieces meant to be shown in a gallery or museum. Sculpture of this type was also loaned or given to hospitals, courthouses, schools, and libraries. An example is Jose de Rivera's stainless steel sculpture *Flight*, a gleaming, stylized representation of a bird on the wing.

The second type of FAP sculpture was "architectural" or "monumental" sculpture. These pieces, often cast in concrete, were created for specific sites such as public parks, playgrounds, public housing, college campuses, and zoos.

FAP graphic artists created more than eleven thousand designs for prints (etchings, lithographs, woodcuts, and posters). Prints had several

advantages over sculpture and paintings. Many copies could be made of one design. Prints were portable and inexpensive. Since prints could be distributed easily and cheaply, they were the ideal medium for reaching the public.

The most noticeable product of depression-era printmaking was the poster. Five hundred WPA poster artists executed 30,500 original designs over the life of the program. Displayed in the lobbies, stairwells, and restrooms of public buildings, WPA posters seemed to be everywhere. They encouraged citizens in wholesome habits such as reading books, eating nutritious foods, and brushing their teeth.

FAP chief Holger Cahill believed that the average person ought to have a chance to learn about art. To teach art to the millions, the

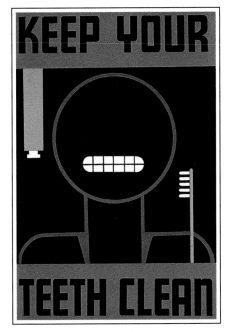 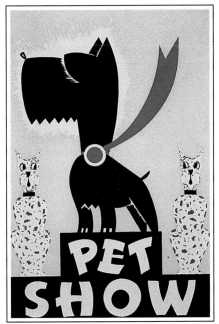

Graphic designers of the FAP created thousands of poster designs. Many offered helpful advice and announced WPA activities. Here, two WPA posters promote toothbrushing and a pet show.

FAP set up more than one hundred community art centers all around the nation. Some offered classes in art appreciation. Most featured gallery lectures and demonstrations of different art techniques. More than three thousand students, black and white, used the gallery and studio of the FAP art center in Harlem, New York. The center's greatest success lay in helping to launch painter Jacob Lawrence and other young black artists.

UP AGAINST THE WALL

The FAP also sponsored murals. Murals drew intense attention because they were so big and so public, spanning the walls and ceilings of hundreds of schools, libraries, post offices, and government buildings nationwide. FAP muralists completed some twenty-five hundred murals. At their best, Holger Cahill believed, these massive works expressed "the experience, history, ideas, and beliefs of a community." Decades later, FAP murals remain the most visible legacy of the artists of the 1930s.

Typical was *Cycle of a Woman's Life,* a mural created in 1936 by Lucienne Bloch. Bloch had been hired to paint a room in the Women's House of Detention in New York City, a grim location for an assignment. As Bloch studied the cheerless, angular space used by women prisoners, she noted "a crying need for bright colors and bold curves to offset this drabness."

A bigger difficulty lay in the attitudes of the inmates. In talking with them, Bloch found the women suspicious of anything having to do with art. Bloch was convinced, however, that she could prompt a positive response:

> Since they were women and for the most part products of poverty and slums, I chose the only subject which would not be foreign to them—children—framed in a New York landscape of the most ordinary kind. It could be Uptown, Downtown, East Side or West Side—any place they chose. The tenements, the trees, the common dandelions were theirs.

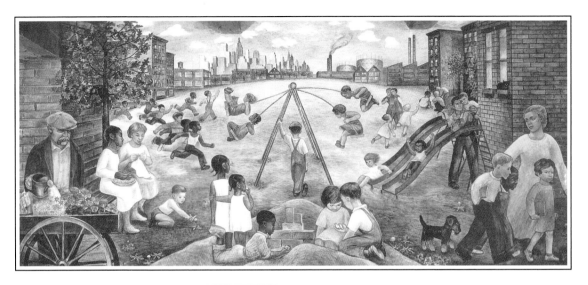

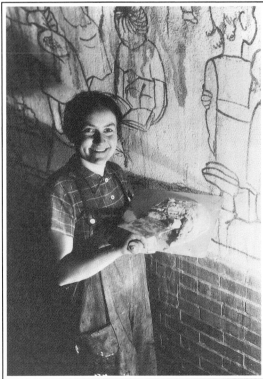

Lucienne Bloch, left, *created her* **mural** Cycle of a Woman's Life, above, *in 1936 for the Women's House of Detention in New York City.*

As Bloch worked on *Cycle of a Woman's Life,* she found the mural had a remarkable effect. The inmates became so fond of the children in the mural that they named and "adopted" the painted figures. The superintendent of the house, who had discouraged Bloch's ideas at first, often stood next to Bloch's scaffold and asked friendly questions about her work. Curious matrons of the house were disarmed because Bloch didn't wear a smock or throw artistic tantrums. To Bloch herself, the experience revealed "to what degree a mural can . . . act as a tonic on the lives of all of us."

Not every mural painted during the depression was received as warmly as Lucienne Bloch's. Some murals were disliked. Some even sparked controversy. In Belleview, Illinois, an FAP artist was forced to take down his mural after residents complained that it made Abraham Lincoln look like Lenin, leader of communist Russia. People in Missouri were dismayed to find that the mural for their state capitol did not feature statesmen and heroes. Instead, the artist had painted the outlaw Jesse James, crooked political leader Boss Pendergast, and other disreputable characters. And when the citizens of Richmond, Virginia, reviewed the plans for a mural in their new parcel post building, they saw nude Confederate soldiers. They protested hotly, and the muralist was obliged to paint trousers on the men.

Most criticism of federal murals came from local people. But sometimes it came from Washington, D.C. For example, Secretary of the Interior Harold Ickes insisted on approving each design for decorative arts for his department's new building. "Everyone knew he would cancel a project if defied," one WPA artist observed. Ickes knew what he liked but not why. When he didn't like the faces of the people in one mural, he vaguely directed the artist to make them "more American."

Perhaps the best-known mural controversy arose in 1934. A new public building, Coit Tower, was being built in San Francisco, California. A month before the tower opened, a group of newspaper editors toured it. They looked forward to seeing a series of colorful

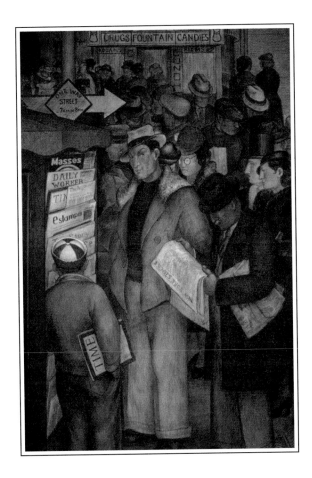

Victor Arnautoff's **City Life** *sparked controversy when people noticed that this section of the mural pictured* **The Daily Worker** *and* **The Masses,** *both communist publications.*

murals on the walls of the lobby and in the stairwells, painted by twenty-five artists of the region's Public Works of Art Project (PWAP). But instead of an artistic expression of American tradition, the visiting editors saw a communist threat.

In one of the murals, *City Life,* artist Victor Arnautoff had painted a busy urban street scene. A robbery at gunpoint was taking place and so was a traffic accident. But what bothered the editors was a newsstand near the center of the mural. Plainly visible in its racks were issues of the communist publications *The Daily Worker* and *The Masses.* Arnautoff wasn't the only artist to make a reference to communism. For example, a

mural by Clifford Wight featured a hammer and sickle, the symbols of the Communist Party.

An agitated PWAP regional official fired off an anxious wire to his Washington superiors. He complained of "details . . . which might be interpreted as communistic propaganda." Edward Bruce, national director of the PWAP, joined local officials in condemning the murals.

The artists did not deny the accusation. Neither were they willing, when asked by the PWAP, to paint out the offending details. Battle lines were drawn.

To support the artists, members of the San Francisco Artists and Writers Union set up a picket line around Coit Tower. For two weeks, they toted signs protesting what they saw as the government's attempt to stifle free speech. The picket line seemed to have the desired effect on public opinion. The scandal began to die down. When Coit Tower opened, most of the offending details in the controversial murals remained intact.

Why had symbols of communism touched off such a furor? To some people, anything "communist" must be "anti-American." The Communist Party/USA was making a strong case that the capitalist system exploited working people. Many workers remained poor, despite working long hours. The party urged workers to fight for their rights by joining unions. Many people, including business and political leaders, felt these ideas, including unionization, threatened the American way of life.

SHAKESPEARE IN HARLEM

The Federal Theater Project, led by Hallie Flanagan, staged twelve hundred productions in front of thirty million people during the four years of its life. FTP touring companies took tragedies, comedies, and other plays to churches, police stations, college auditoriums, and public parks in towns in several states. For younger audiences, local FTP units staged such children's favorites as *Rip Van Winkle* and *Pinocchio*.

Perhaps one of the most noteworthy of the FTP projects was the Negro Theater. The Negro Theater was intended to address the needs of black actors, directors, and playwrights, who had been largely left out of mainstream theater. Until the mid-1930s, Broadway had staged no more than seven productions written by black playwrights.

The Negro Theater had units in eleven cities. The black actress Rose McClendon and the white producer John Houseman were tapped to codirect the unit in Harlem in New York City. Setting up shop in the Lafayette Theater, they hired a little-known twenty-year-old to direct several productions. His name was Orson Welles.

The most important Houseman-Welles collaboration was a stunning new version of William Shakespeare's play *Macbeth,* a tragedy set in Scotland. Never before in theater history had a black company mounted a full-scale Shakespearean production.

This version of *Macbeth* changed a number of significant details. For example, the setting became nineteenth-century Haiti, where black

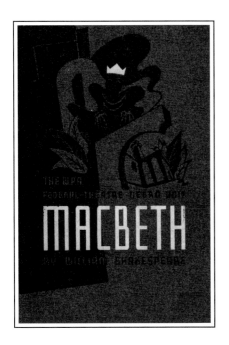

A WPA poster announces a performance of Shakespeare's Macbeth. *John Houseman and Orson Welles revised the play so that the plot took place in Haiti rather than in Scotland.*

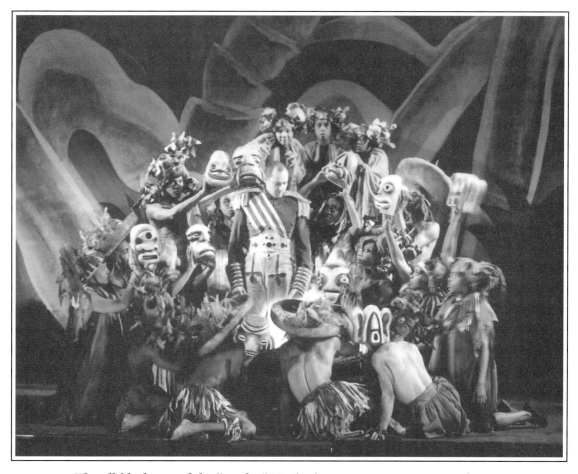

The all-black cast of the "voodoo"* Macbeth *wore costumes patterned on those of African cultures.

slaves born in Africa then lived. Featured were an all-black (and mostly amateur) cast, an authentic witch doctor, and a troupe of African drummers. Since the play also included props and other references to African religious cults, some critics called the production a "voodoo" *Macbeth.* They loved it. So did audiences. White as well as black theatergoers packed the Lafayette night after night to see this daring treatment of Shakespeare's classic tragedy.

CONCERTS FROM WASHINGTON

Joining the multitude of other artists in the not-so-exclusive club of the unemployed were tens of thousands of singers, bandleaders, instrumentalists, and music educators. The Federal Music Project was established with these artists in mind. Led by Russian-born violinist and conductor Nikolai Sokoloff, the FMP had provided jobs for nearly eight thousand musicians by 1939. They were placed in symphony orchestras, dance bands, chamber music ensembles, opera units, and other musical groups.

Where no music organizations existed, the FMP simply created them. Across the country, the project set up both symphony orchestras and vocal ensembles. Other FMP workers copied music scores in India ink for use by orchestras and choruses.

Sokoloff and his directors did not ignore education. Some six thousand music instructors taught nearly fourteen million students. Schoolchildren, teens, and adults studied folk music, dancing, music theory, composition, music history, and conducting.

Critics of the program scoffed at the idea of "giving music lessons to housewives." The FMP, however, defended its instruction as being serious. "A student coming in for [only] a slight knowledge of piano, voice or violin, soon discovers that he does not belong," stated one FMP report. "He must learn to listen, analyze, even create, as well as play." The best news to depression-era music students was the price. All FMP classes were free.

ESCAPE FROM HARD TIMES

In an era of bread lines, Depression and wars, . . . I wanted to make people happy, if only for an hour.
—Busby Berkeley, 1930s movie director and choreographer

The summer of 1935 found Benny Goodman and his orchestra on a long, cross-country tour. Fresh from a stint on the *Let's Dance* radio series, Goodman's band had played their hot, hard-driving jazz everywhere they went. They wanted audiences to hear a sound very different from the mellow, sweet-sounding jazz people were used to.

The results were not good. In New York City and in Pittsburgh, Pennsylvania, the group was asked to quiet down. At a club in Denver, Colorado, irritated patrons asked for their money back. In Milwaukee, Wisconsin, and Salt Lake City, Utah, audiences voiced their preference for sweet jazz. The poor reception in town after town plunged the group's morale to an all-time low. They switched to a calmer style.

In late August, the band arrived in Los Angeles, California. Their final "gig" was at the Palomar Ballroom, the most famous jazz hall on the West Coast. On August 21—their first night at the Palomar—they played their sweet tunes. But the audience seemed indifferent.

Watching the unresponsive faces in front of him, Goodman decided to go for broke. "For all I knew, this might be our last night together," he said later. "If we had to flop, at least I'd do it . . . playing the kind of music I wanted to." He brought out several arrangements written by bandleader Fletcher Henderson and launched the orchestra into the "King Porter Stomp." With Gene Krupa on drums and Bunny Berigan on trumpet, the group's hot sound spilled out over the room. And the audience went wild.

That night at the Palomar is sometimes considered the birthday of a kind of music that came to be called "swing." Benny Goodman and his orchestra went on to produce swing hits such as "Sing, Sing, Sing" and "Stompin' at the Savoy." It wasn't long before Goodman was crowned the "King of Swing."

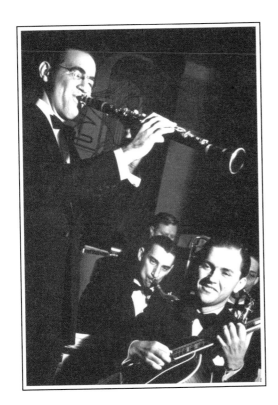

Benny Goodman, left, and his orchestra swing at the Hotel Pennsylvania in New York City in 1938. Swing musicians were among the first to be mobbed by enthusiastic fans.

Swing was a tonic for young people, burdened by troubles such as not having enough money for clothes or school supplies. Earlier forms of jazz had not been easy to dance to. But legions of fans, especially teenagers, found people could dance to swing. And dance they did, equipping the swing craze with new dances and its own "jive" vocabulary. Across the country, adolescent "alligators" and "hepcats" mobbed dance halls to "cut the rug." Perplexed parents shook their heads while their teens spun, crouched, and kicked to the "Big Apple," the "Lambeth Walk," and the "Lindy Hop."

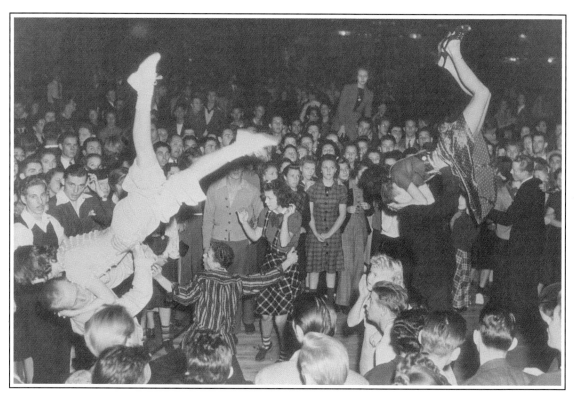

Energetic young people dance the jitterbug in Ocean Park, California, in February 1939. For capturing this moment, photographer Paul Pangburn of the **Los Angeles Herald and Express** *won third prize in a contest sponsored by the Hearst newspaper chain.*

The standard big band featured five brass pieces (trumpets or cornets, and trombones), four reeds (saxophones and clarinets), and four rhythm instruments (usually piano, guitar, bass, and drums). The rhythm section laid down a steady background. The brass and reed sections, meanwhile, took turns playing a tightly harmonized melody in a "call-and-response" pattern. Hot soloists improvised their own versions of the tune.

Swing became the first jazz form to attract a broad commercial audience of white, middle-class, as well as black, listeners. At a time when white and black citizens were often segregated—relegated to separate schools, drinking fountains, and other public facilities—swing pointed out a common human truth. Most people love to dance.

Besides, despite FDR's aggressive programs, economic conditions were slow to change. People needed inexpensive ways to have fun and to forget their troubles. Swing's sound, wild by the standards of the 1930s, had a liberating effect, especially for teens. Moving to the beat of the "cats" onstage with their "canaries" at the mike, teens must have felt the depression was far away indeed.

ON THE AIR

Television did not exist in the 1930s. But almost everybody was hooked on another form of entertainment: the dynamic young medium of radio. A wide variety of programs were only a twist of the dial away. And they came into people's homes for free.

Hard times may have forced people to part with their cars or their furniture, but the family radio was another matter. One Kentucky woman recalled that her family owned a battery-powered Philco radio. "It was a prized possession and we cared for it with tenderness," she said.

For many listeners, comedy was radio's main attraction. Will Rogers helped people find the humor in the way the boom years of the 1920s had become the Great Depression. "We are the first nation in the history of the world," he quipped, "to go to the poorhouse in an automobile." Other popular comedy performers were Jack Benny, the team

of George Burns and Gracie Allen, and ventriloquist Edgar Bergen with his dummy Charlie McCarthy.

Dramatic programs with heroes, heroines, and villains also had an enthusiastic following. Audiences in any era are attracted to a courageous individual who fights to keep society safe. During the Great Depression, the archetypical hero may have had particular appeal to members of a society in turmoil.

"Who knows what evil lurks in the hearts of men?" was the chilling opening line for *The Shadow,* a suspense series. The Shadow was a hero draped in a cloak who fought crime and solved baffling mysteries.

A western hero was supplied by *The Lone Ranger* series. The title character was a masked cowboy who rode a mighty stallion named Silver. The Lone Ranger was always accompanied by his Indian friend, Tonto. Together, they brought stability to the "Wild" West.

Soap operas like *Our Gal Sunday* appealed to housewives who yearned for a romantic diversion from the everyday challenges of running a household on a tightened budget. One New York woman recalled that in summertime, neighborhood women "could walk all the way around the block" and still hear their favorite soap operas. "Every front door was open with the radio on," she recalled. "Even though we were outside, we never missed a word of the stories!"

THE DEPRESSION GOES HOLLYWOOD

For the ultimate in escapism, there was nothing like the movies. Inside a dark movie theater, with giant images flickering on the screen up front, people could forget the pain, loss, and uncertainty outside. "Back then we didn't need realism [in movies]," one Wisconsin moviegoer later recalled. "We got plenty of realism once we walked out of the theater and back into those tough times." *The Wizard of Oz, Snow White and the Seven Dwarfs,* and *Gone with the Wind* were just a few of the movies that transported audiences away from the grim world of the depression.

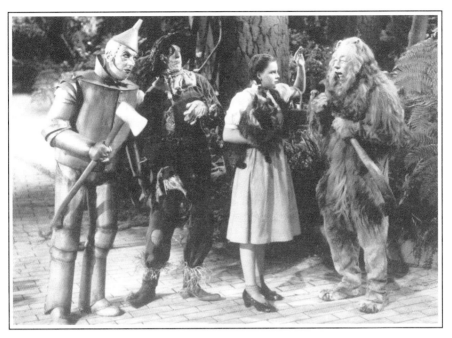

Many movies of the 1930s helped people escape the dreariness of everyday life. In **The Wizard of Oz (1939),** *the Tin Man (played by Jack Haley Jr.), the Scarecrow (Ray Bolger), Dorothy (Judy Garland), and the Cowardly Lion (Bert Lahr) all achieved their dearest wish.*

The movie moguls of the 1930s were not artists themselves. They were businessmen. Darryl Zanuck, head of Twentieth Century-Fox, once visited a famous art museum, the Louvre, in Paris, France, and commented, "We've got to be out of this joint in twenty minutes." Well-known director George Cukor commented, "If you are primarily concerned with something that is usually called personal artistic integrity, you don't belong in the business of making commercial pictures. You should get yourself a paint-brush or a typewriter."

To be a money-making venture, a movie in the 1930s had to compete well for the few dollars people had to spend. In planning a movie, not only studio heads but also playwrights, actors, and others looked for the plot, setting, and characters that would most likely

draw Americans away from the real world for an hour or two. No one could define exactly why audiences flocked to comedies, love stories, gangster movies, and others. But Elder Hays, president of the Motion Picture Producers and Distributors of America, Inc., believed movies could serve a crucial role in a critical time, as long as they reflected solid American values. Commenting in the mid-1930s, he said:

> No medium has contributed more than the films to . . . national morale. . . . It has been the mission of the screen, without ignoring the serious social problems of the day, to reflect aspiration, achievement, optimism, and kindly humor in its entertainment. Historians of the future will not ignore the interesting and significant fact that the movies literally laughed the big bad wolf of depression out of the public.

JUST FOR LAUGHS

Particularly popular was one new movie genre concocted just for the 1930s. It threw two people from different social classes together in an unlikely and often hilarious situation. The genre was "screwball" comedy, and its king was Frank Capra. Capra possessed, said one critic, "the rare gift of capturing on film the mood of his country at the time."

The Italian-born Capra had broken into the movie business in the 1920s as a gag writer and director of silent comedies. Then in 1933, he and screenwriter Robert Riskin began fashioning a short story titled "Night Bus" into *It Happened One Night,* one of the leading films of the 1930s. The story followed an out-of-work reporter who encounters a famous heiress who has grabbed headlines by running away from home. Clark Gable and Claudette Colbert were cast in the lead roles as Peter Warne and Ellie Andrews. When Peter learns that Ellie is the famous runaway, he offers to help her reach her fiancé in New York City. In return, she must give him an exclusive story about her flight. Temporarily broke, Ellie agrees.

At first, Peter is disgusted by Ellie's wealth and snobbery. In one scene, he scornfully teaches her the "proper" way to dunk a doughnut in her coffee. "Twenty million dollars and you don't know how to dunk!" he sneers. Another famous scene has Peter demonstrating to Ellie his best thumb-jerking hitchhiking techniques. To his dismay, motorists ignore him. Ellie steps to the road and shows her leg, stopping the very next car. A smug Ellie informs a fuming Peter that "the limb is mightier than the thumb." Obviously, the two are falling in love. In New York, Ellie leaves her bridegroom at the altar and rushes off to marry Peter instead.

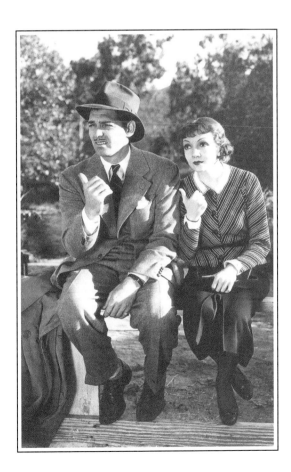

In **It Happened One Night,** *Clark Gable and Claudette Colbert appeared in one scene as impeccably dressed hitchhikers. Movie fans in the 1930s copied the clothes and hairstyles of their favorite stars as much as possible.*

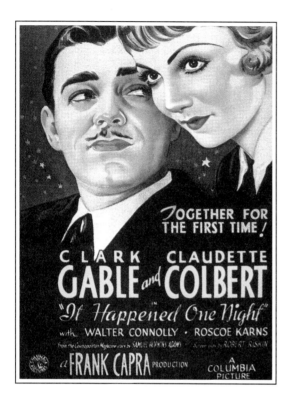

A rich girl (played by Claudette Colbert) had a lot to learn from an ordinary guy (played by Clark Gable) in Frank Capra's film It Happened One Night *(1934). She also taught him a thing or two.*

It Happened One Night was the surprise hit of 1934. Audiences loved the tale of an ordinary guy reforming a rich, spoiled brat, and the picture swept all top five Academy Awards for the year.

Another style of movie comedy was perpetrated upon an unsuspecting public by the Marx Brothers: Groucho, Chico, Harpo, and Zeppo. In pictures such as *A Night at the Opera,* the slapstick gags of Chico and Harpo reduced peace and order to chaos. Meanwhile, the cigar-wielding Groucho fired off one-liners. Often he deflated members of the social elite—a common depression-era theme. For example, in the movie *Duck Soup,* Groucho chats with the snobbish widow of a ruler who has just died:

> She: I was with him to the very end.
> He: No wonder he passed away.

She: I held him in my arms and kissed him.
He: Oh, I see. Then it was murder.

As comedians thumbed their noses at the "big bad wolf" of the depression, their bravado must have encouraged those who felt overwhelmed by a force much larger than themselves. Commenting on a song that epitomized the frightening force of the depression—"Brother, Can You Spare a Dime?"—Groucho once quipped, "[The title] was originally 'Brothers, Can You Spare a Dime?' But this was spreading a dime pretty thin, so they threw out one brother [and] gave all the money to the other one." Scared of the depression? The message was clear. Not when you can laugh at it instead.

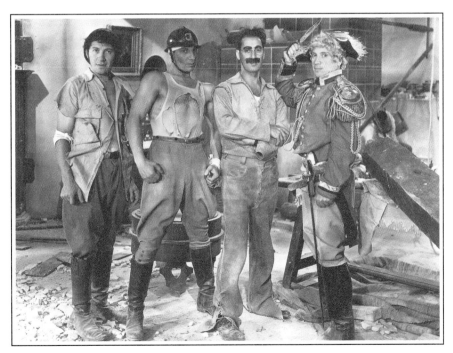

The Marx Brothers—Chico, Zeppo, Groucho, and Harpo—in **Duck Soup.** *They kept audiences roaring with laughter, a welcome relief from the depression.*

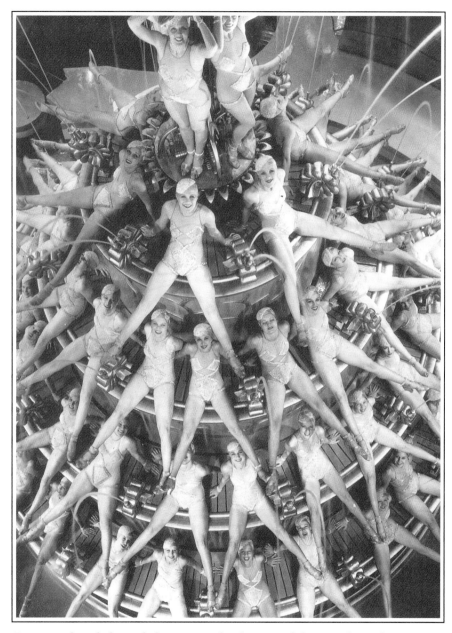

Fans stood and cheered the spectacular beauty of this revolving fountain in Busby Berkeley's movie Footlight Parade.

SPECTACULAR MOVIES

In 1933 Warner Brothers brought out the first of a new kind of movie musical. Titled *42nd Street,* the film introduced plot elements that were to become classic. A Broadway director struggles to mount a new musical complete with show-stopping dance numbers. A temperamental star can't go on with the show. And a newcomer steals the spotlight. The real star of these pictures was a man who never appeared on screen, director and choreographer Busby Berkeley.

For Berkeley, entertainment meant spectacle. He achieved it with oversized sets, glittering costumes, and pretty chorus girls in abundance. Berkeley's fantastic dance routines were far too complex to fit on the stage of a theater. With legions of dancers, gigantic props, and shifting scenes, they could be captured only on film. Explaining his lavish approach, Berkeley commented, "In an era of bread lines, Depression and wars, . . . I wanted to make people happy, if only for an hour."

Footlight Parade showed the Berkeley flair for spectacle at its most astonishing. The film's most famed number opens in a shady glade where actor Dick Powell croons "By a Waterfall" to actress Ruby Keeler. Behind them, twenty thousand gallons of water per minute tumble over a backdrop of artificial rocks into a "natural" pool. Plunging in, Keeler is joined by one hundred diving and water-sliding "nymphs." Then the scene abruptly changes to reveal a manmade pool. Viewed from an overhead camera, the swimmers regroup into a human kaleidoscope—soon to be a Berkeley trademark. The number ends with the water nymphs posed on a five-tiered revolving fountain. The people who attended *Footlight Parade*'s New York City premiere were so awed by this sequence that they stood and cheered.

THE DUST BOWL

Our pride isn't all gone. If we have a chance we can care for ourselves and be happy.
—a California mother of seven during the Great Depression

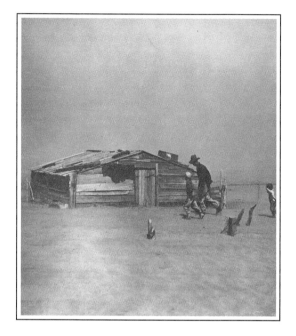

After a relentless gray rain had hammered the farm country of California's San Joaquin Valley for weeks in 1937, miles of farm fields, vineyards, and orchards lay mired in mud. No work could be done in the fields. With nowhere else to go, the migrant workers who were on hand to tend the crops were forced to sit idle and unpaid. Most were penniless. Their families, living in ramshackle camps of flimsy tents and shacks, were hungry and ill.

One man visiting such a camp in Visalia, California, that year was appalled by conditions there. "The water is a foot deep in the tents. . . . There is no food and no fire," novelist John Steinbeck wrote to an associate. "In one tent there are twenty people quarantined for small pox, and two women are to have babies in that tent this week."

A native Californian, Steinbeck was no stranger to the plight of the state's agricultural workers. He had already described their struggles in two novels, *In Dubious Battle* and *Of Mice and Men.* But the troubles of the San Joaquin workers especially disturbed him. Most had come to California from Arkansas, Texas, Nebraska, Kansas, and Oklahoma. Many of these displaced people had owned their own farms. But years of drought had parched the Great Plains. Wind whipped the loose, dry soil into ravaging dust storms so often that the region was called the "Dust Bowl." Crops failed. Thousands of people went into bankruptcy, lost their farms, and found themselves homeless.

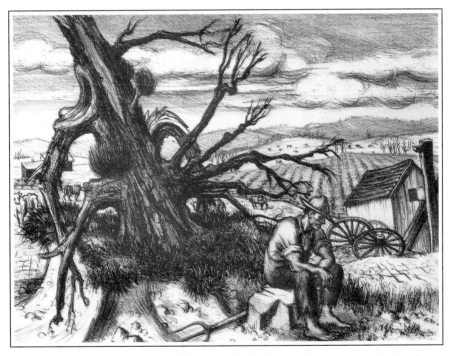

From 1933 to 1937, one million people fled a prolonged drought in the Plains states to seek work in California. **Drought, above,** *a lithograph by Jacob Kainen, and the photograph,* **left,** *by Arthur Rothstein give two artists' impressions of the Dust Bowl.*

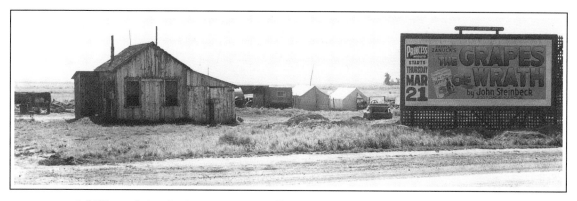

A billboard in the San Joaquin Valley in California advertises the movie based on John Steinbeck's novel **The Grapes of Wrath.** *By juxtaposing art and real life in this photograph, photographer Dorothea Lange artfully underscored the power of Steinbeck's message.*

Between 1933 and 1937, a torrent of Dust Bowl refugees—one million men, women, and children in all—streamed into California, where they hoped to earn a living in the state's many fields and groves. But huge corporations controlled the state's agricultural industry and could choose among hundreds of laborers competing for each job. The competition helped keep wages impossibly low. The bad situation worsened when the rains of 1937 turned California's croplands into swamps of mud, all but useless for farming.

Ignoring the ceaseless downpour, Steinbeck set to work in Visalia. For two weeks, he labored alongside agents of the Farm Security Administration to distribute food and to aid the sick. Then, saddened and angry, he returned home and began to write.

He wanted this new story to be his "big book." Twice before he had begun writing it; twice he had discarded the manuscripts in frustration. "If only I could do this book properly," he had confided to his diary, "it would be one of the really fine books and a truly American book." With the memory of Visalia painfully fresh, Steinbeck at last began crafting the story that had eluded him for so long—a story he called *The Grapes of Wrath.*

His hero became young Tom Joad. Newly paroled from prison, Tom learns that his family has been forced off their Oklahoma farm. Loading up their rickety truck, the Joads set off for California. Steinbeck described the isolation people like the Joads felt, writing, "One man, one family driven from the land; this rusty car creaking along the highway to the west. I lost my land. . . . I am alone and I am bewildered."

After reaching California, the Joads discover there is not enough work for everyone. Describing the desperation prompted by the job shortage, Steinbeck wrote:

> When there was work for a man, ten men fought for it—fought with a low wage. If that fella'll work for thirty cents, I'll work for twenty-five. If he'll take twenty-five, I'll do it for twenty. No, me, I'm hungry. I'll work for fifteen. I'll work for food.

One of the Joads' companions, a disillusioned preacher named Jim Casy, is not content to suffer peacefully. And he refuses to face an unjust situation alone. One man alone has little chance against giant corporations, Casy reasons. Workers must band together in unions to challenge an oppressive system. For Casy, hope is found in the group rather than in the individual.

Casy leads a group of laborers in a strike against their employer to protest low wages. Tom is visiting the strikers' camp one night when a squad of thugs, sent by the employer, attacks them. Casy is murdered. Seeking vengeance, Tom kills Casy's murderer. Tom must flee. But first, he goes to his mother. Stinging from the injustice of all that has happened, Tom expresses his sense of kinship with the workers. "Maybe like Casy says," Tom tells Ma, "a fella ain't got a soul of his own, but only a piece of a big one." Tom later carries on the union work begun by Jim Casy. Ma continues her own crusade: keeping her family together during hard times.

Written in a five-month burst of effort, Steinbeck's novel *The Grapes of Wrath* was published in April 1939. It became a bestseller

overnight and won the Pulitzer Prize for fiction the following year. Twentieth Century-Fox released a motion picture based on the novel, and folksinger Woody Guthrie wrote and recorded a song titled "The Ballad of Tom Joad." Perhaps Americans, vulnerable and wary, embraced *The Grapes of Wrath* so wholeheartedly because many shared the view of Jim Casy and Tom Joad, that people needed to unite in order to survive. *The Grapes of Wrath* held up a mirror to the suffering of the decade. Americans looked into the mirror and saw themselves.

PICTURES THAT MOVE

Documentary filmmakers joined artists like John Steinbeck in providing a vividly realistic portrait of the Dust Bowl. With funding from Federal One, one twenty-nine-year-old filmmaker, Pare Lorentz, set out to make the first important documentary film of the 1930s, *The Plow that Broke the Plains.* Its stark images of the Dust Bowl would haunt the nation.

The film opens with pale oceans of grain stretching across the screen as breezes send ripples across their surfaces. Tractors and combines lumber through acres of wheat and barley. This is American heartland in richness and plenty. Then the scene changes. A single plow gouges a shallow furrow in sandy soil. Farm equipment lies broken and idle. Small eddies of dust spin over the sun-scorched earth. The background music shifts to a darker tone. The wind rises, and a dust storm begins. Children and a farmer run through the swirling clouds. Angry waves of dust sweep across the prairie, blanketing farmlands and houses alike.

"Year in, year out," narrator Thomas Chalmers intones, "they fought the worst drought in history." Anxious children watch their father hopelessly shoveling dust. "Many stayed—until stock, machinery, homes, credit, food, and even hope were gone." The defeated family loads its belongings on a truck and drives away. "Blown out— baked out—and broke," continues the narrator. "Nothing to stay for,

This film still from the **The Plow that Broke the Plains** *(1934) by Pare Lorentz conveys his message. Dust Bowl farmers were "blown out—baked out—and broke."*

nothing to hope for. Homeless, penniless and bewildered, they joined the great army of the highways." An endless line of broken-down cars creeps westward. The music settles into a slow, mournful cadence for the finale. "All they ask is a chance to start over, and a chance for their children to eat, to have homes again."

The major Hollywood studios refused to show *The Plow that Broke the Plains* in any theater chain they owned. After all, they believed, entertainment, not raw facts, filled their theaters. Finally, an independent New York theater agreed to show the film, and critics raved. Within a year, some three thousand theaters had screened Lorentz's masterpiece. Lorentz had found a way to express his view of Americans in moving pictures—and moved his audience.

FROM FRONT PAGE TO CENTER STAGE

Throughout the depression, unemployment, hunger, corruption, and poverty were daily news. Adversity and conflict are central to drama, so the daily newspaper was an excellent source for live theater material. From this reasoning came the concept of the "Living Newspaper." Established in cooperation between the FTP and the

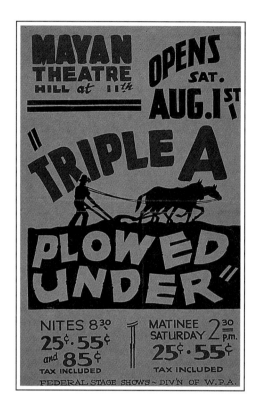

Triple A Plowed Under *was one of many Living Newspaper productions. They all combined live actors, film slides, and special effects such as the voice of an unseen narrator in unique, multimedia presentations.*

Newspaper Guild in 1936, the Living Newspaper project produced plays based on issues that affected the average 1930s American.

FTP staff writers pored over newspapers, magazines, government reports, and books. After carefully selecting news items, they used them as the basis for a multimedia production. Living Newspaper productions had no single, continuous story line. Instead, they were a patchwork of sketches and comedy with live actors, blackouts, film slides, and music. Not surprisingly, this new theater form challenged performers and audiences alike.

One Living Newspaper production was called *Triple A Plowed Under.* Like *The Grapes of Wrath* and *The Plow that Broke the Plains,* it also explored the plight of farmers in the Dust Bowl. (The term "triple A" referred to the grade of quality assigned to tracts of farmland.) In one

sketch of *Triple A Plowed Under*, a voice echoes out of a loudspeaker. "Summer, 1934," it announces. "Drought sears the Midwest, West, and Southwest." An actor portraying a farmer kneels in the setting of a rain-thirsty field. The voices of unseen people announce increasingly bleak weather reports. As the music builds, the farmer lets a fistful of earth drain through his fingers. "Dust!" he says. In another sketch, a desperate woman stands trial for the drowning of her small son. "Why did you do it?" an offstage voice demands. "I couldn't feed him," the woman replies. "I had only five cents."

Audiences were enthralled by the drama and inventiveness of the Living Newspaper. One theater critic hailed the Living Newspaper format as "the one original form of drama developed in the United States."

DOCUMENTING AMERICA

I'd tell the photographers, look for the significant detail. The kind of things that a scholar a hundred years from now is going to wonder about.
— Roy Stryker, Resettlement
 Administration, 1935

On a raw evening in March 1936, a car sped along a lonely highway in central California. At the wheel was a forty-two-year-old professional photographer named Dorothea Lange. Fatigued after weeks of traveling and snapping pictures, Lange had one thing on her mind. "I felt freed," she later recalled, "for I could lift my mind off my job and think of home." The miles flashed by.

Then a rough sign bearing an arrow and the words "Pea Pickers Camp" caught Lange's eye. Lange had spent the last month photographing conditions of laborers in that region for the Farm Security

Administration. What could one more group of exhausted, hungry workers add to the pictures she already had? Besides, there was home, only seven hours away. Lange drove on.

Yet there was something about that sign she could not shrug off. Twenty miles later, she turned around. "Almost without realizing what I was doing, . . . I went back those twenty miles and turned off the highway at that sign . . . ," Lange said. "I was following instinct, not reason."

Returning to the sign, Lange found the all-too-familiar layout of a migrant camp—rows of crude tents and flimsy shacks in a soggy bed of mud, no electricity, no running water. Among the tired, unkempt residents, a thin woman sat in a lean-to of patched canvas. Scattered

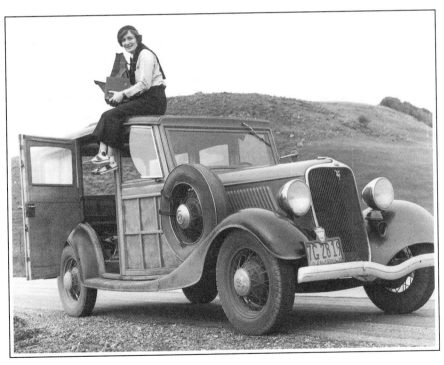

Opposite: *A documentary photograph by Ben Shahn.* **Above:** *Dorothea Lange in California in February 1936.*

around the tent were chairs, a makeshift table, and three unwashed children. Lange recalled:

> I saw and approached the hungry and desperate mother, as if drawn by a magnet. I do not remember how I explained my presence or my camera to her, but I do remember she asked me no questions.... She told me her age, that she was thirty-two. She said that they had been living on frozen vegetables from the surrounding fields, and birds that the children had killed. She had just sold the tires from her car to buy food.

Lange made five careful exposures of the luckless family. In one of the shots the mother sits calmly, her baby in her lap and her older children draping her shoulders. As she gazes out at the horizon, she almost seems to be looking warily toward an uncertain future.

That photo, which Lange titled *Migrant Mother*, caught the world's imagination. It was published again and again in newspapers and magazines across the globe and "established without doubt," according to one writer, "the moving, persuasive power of a photograph."

HISTORY AT SHUTTER SPEED

The idea of using pictures to record the story of the Great Depression came not from a photographer, but from a New Deal politician. Rexford Tugwell, undersecretary of agriculture in the Roosevelt cabinet, held the reins of the Resettlement Administration. The RA needed funding from Congress, and Congress needed convincing. To keep the dollars coming, Tugwell decided to provide a photographic record of the agency's work.

For this task he turned to Roy Stryker, an economics professor at Columbia University in New York City. Like Tugwell, Stryker saw the project as more than a way to guarantee funding. It was a unique chance to document the depression with photographs.

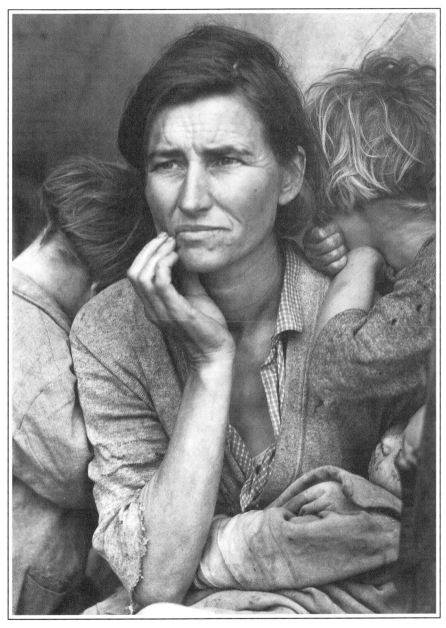

The dignity of **Migrant Mother** *(1936) by Dorothea Lange helped make it one of the most enduring images from the Great Depression.*

In mid-1935, Stryker assembled a crack team of photographers who would work under the RA's historical unit. The first to come on board was darkroom expert Arthur Rothstein. He was followed by photojournalist Carl Mydans and Walker Evans, a national magazine photographer. Next came photographer Dorothea Lange and Ben Shahn, an artist renowned for his paintings, but new to photography.

His team complete, Stryker sent them out across the nation. "I'd tell the photographers, look for the significant detail," he recalled. "The kind of things that a scholar a hundred years from now is going to wonder about. . . . Crank-handle telephones. Front porches. . . . Symbols of the time." As the photographers snapped pictures, they mailed roll after roll of film back to RA offices in Washington, D.C.

The result was nearly 270,000 black-and-white photos taken over a period of seven years. Sometimes camera shutters captured images of poverty (such as hungry migrant workers and dirty children peering out from the doorways of shacks) or struggle (the black, boiling clouds of a dust storm). Other subjects were cheerful (the inviting interior of a country story). The locations included a filling station in Georgia, a Victorian house in Ohio, an industrial town in Pennsylvania—and many more.

The photos served their original purpose. They helped convince Congress to keep the RA (and later the FSA) funded. But something larger emerged from them. The pictures sent back by these photographers wrote a new chapter in documentary history.

INDEXING AMERICA

The Federal Art Project also took a keen interest in documenting America. FAP chief Holger Cahill was an expert on American folk art. He was convinced that the nation possessed a rich, if little-known, artistic heritage. To prove it, he enlisted the aid of a textile designer and the head of the picture collection of the New York Public Library to create the Index of American Design. Its purpose was to create a visual record of the work of U.S. artists and craftspeople from the earliest days of the nation.

To capture the rich details of American culture, artists of the Index of American Design made painstaking drawings of American arts and crafts. This wood-block print of the Annunciation to the Virgin *was printed and hand colored in 1936 by WPA artists for the Index of American Design, New Mexico.*

Research teams in thirty-five states scoured the country for examples of American craftsmanship in furniture, textiles, ceramics, woodwork, metalwork, and clothing. They studied pioneer tools and furniture of the Midwest. Shaker crafts came under their scrutiny in New England and New York. In the Southwest, they collected samples of Spanish woodcarving and weaving.

Then artists with a keen eye for detail and form spent hours painstakingly copying each design in watercolor, oils, or pen and ink. Quilts, weathervanes, tavern signs, stoneware jugs, and even cigar-store Indians were captured for history by the skillful hands of project artists. When the Index of American Design was finished, the FAP

had visual proof that the roots of American art were firmly planted in American soil.

At the Federal Music Project, director Nikolai Sokoloff assembled a group with a similar mission. His workers compiled an extensive almanac of twenty-two hundred native composers and seven thousand of their works called the Index of American Composers. Still other FMP workers collected and catalogued samples of American folk music from all parts of the United States.

In a similar vein, the Federal Writers Project began several impressive undertakings, including its own black studies program. The project

Married ex-slaves Tap and Susie Hawkins stand in front of their Ohio home in 1937. Many former slaves like the Hawkins couple were interviewed for the black studies program of the Federal Writers Project.

was not content to merely echo the history of the Civil War and Reconstruction as written by white men. This time FWP workers, both black and white, gathered information directly from the many former slaves who were still living. Theirs was the first major oral history project undertaken in the United States.

Directed by folklore expert John Lomax, three hundred FWP members fanned out across seventeen states to interview more than two thousand ex-slaves. Much of what the interviewers heard surprised them. Contrary to what many white Americans thought, freedom for the slaves in 1865 did not mean instant happiness. "Slaves prayed for freedom," recalled eighty-four-year-old Patsy Mitchner of North Carolina. "Then they got it and didn't know what to do with it. They was turned out with nowhere to go and nothing to live on. They had ... nothing to work with, and no land." Revelations like this one gave the interviews a different and perhaps truer picture of the black experience. The FWP slave narratives forced historians and sociologists to take a fresh look at the impact of the institution of slavery on U.S. culture.

Project writers also documented voodoo and Creole lore from Louisiana. They gathered Spanish-American folk songs in New Mexico. From South Carolina and Alabama came selections of Negro spirituals. The FWP published these bits of cultural history in scores of books and pamphlets. In their entirety, these immense oral history projects set a new direction for the way the United States would examine itself for decades to come.

The Federal Writers Project helped to launch many writers who went on to have enduring careers. Among FWP workers were Saul Bellow, Ralph Ellison, Zora Neale Hurston, and Richard Wright.

THE AMERICAN GUIDES

The Federal Writers Project, directed by journalist Henry G. Alsberg, employed more than sixty-five hundred workers. Its most famous endeavor was an ambitious series of books documenting every nook and

cranny in the United States. In the series, called the American
Guides, FWP writers created a guidebook for each of the forty-eight
states that were then part of the United States, plus the territory of
Alaska. In addition, they wrote guides about urban areas like New
York City and natural locales such as Cape Cod in Massachusetts and
Death Valley in California.

To gather material, FWP researchers and authors visited hundreds
of towns and talked to countless local residents. Out of this wealth of
details and images emerged a portrait that was sometimes uplifting,
sometimes critical, but always unique.

The Idaho guide, for example, offered an offbeat look at the
Naked Truth Saloon in Boise. The saloon's owner brashly an-
nounced that he was in the business of making "drunkards, paupers,
and beggars" and aimed to "prepare victims for the asylum, poor
farm, and gallows." The North Carolina version profiled the inven-
tor of a self-kick-in-the-pants machine. "If you feel you deserve 'a
good swift kick,'" the guide instructed, "turn the handle ... and a
huge shoe laced to an iron leg would administer the boot." A col-
orful description of the beach at Coney Island was featured in the
New York guide:

> Bathers splash and shout in the turgid waters close to the
> shore; on the sand, children dig, young men engage in
> gymnastics. . . . Lunch combines the difficulties of a picnic
> with those of a subway rush hour. . . . The air is heavy with
> mixed odors of frying frankfurters, popcorn, ice cream, cot-
> ton candy, corn-on-the-cob and knishes (Jewish potato
> cakes).

By the time the guides appeared, the depression economy was
lumbering toward recovery. Cars were easier to afford. A nearly
finished highway system and the convenience of the new "motor
hotels" (motels) made auto travel suddenly more popular. The
American Guides made the most of this trend, and the public wel-
comed them.

Despite jeers of "make-work" and "extravagant" from critics, the WPA/Federal One arts projects served a real, even unexpected, purpose. First, they did employ thousands of jobless artists. Just as important, Federal One projects explored and recorded facets of the country's history and heritage. Through drama, folk art, photography, documentary film, and travel guides, the arts projects studied the character of a people and a nation. Because of these efforts, Americans knew themselves better than ever before.

CONSCIENCE AND CONTROVERSY

The white spire of the Washington Monument wavered upside-down on the looking-glass surface of the reflecting pool. The Lincoln Memorial stood half a mile away. Between the two memorials, seventy-five thousand people stood elbow to elbow to hear the voice of one woman. This city, Washington, D.C., had never seen anything like the turnout for this extraordinary event.

Born poor, contralto Marian Anderson had worked for years to train her voice to meet the rigorous demands of classical and operatic singing. In 1936 Anderson had been invited to sing at the White House. Three years later, her army of fans was immense. The

In a groundbreaking concert in 1939, Marian Anderson sings on the steps of the Lincoln Memorial in Washington, D.C. She is also pictured at left.

only facility in Washington big enough to hold the crowds she drew was Constitution Hall. But when concert organizers asked for the use of the hall, the hall's owner refused. The Daughters of the American Revolution (DAR) rented no space to Negro performers. And Marian Anderson was black.

Outrage echoed from every corner of the country. First Lady Eleanor Roosevelt resigned from the DAR. At her urging, the Roosevelt administration offered the use of the Lincoln Memorial. So it was that Marian Anderson stood on the steps of the memorial with a lone pianist, facing a sea of expectant faces. "All I knew as I stepped forward," Anderson said later, "was the overwhelming impact of that multitude. . . . I had a

feeling that a great wave of good will poured out from these people, almost engulfing me." When the final note of the twenty-minute performance died away, musical history had been made. "When I sang that day," Anderson recalled, "I was singing to the entire nation."

"FEW PEGS TO FALL"

"When the crash came in 1929," wrote the black poet Langston Hughes, "the Depression brought everybody down a peg or two. The Negroes had but few pegs to fall." The majority of African Americans in the 1930s lived in the South, the poorest section of the country. Segregation was the order of the day. For example, blacks were not permitted to attend schools with whites, to sit with whites on trains and buses, or to share lunch counters and restaurant spaces with whites. Conditions were only slightly better for blacks in the North.

Black artists and performers enjoyed no protection from this discrimination. When black vocalist Billie Holiday went on tour with

*Billie Holiday encountered harsh
segregation while on tour with
Artie Shaw's orchestra.*

Artie Shaw's orchestra, she found that some restaurants refused to serve her. Some hotels barred her, even though they accepted the rest of the musicians, who were all white. In some cities, Holiday had to stay out of sight offstage whenever the orchestra performed numbers without her.

A still more sinister aspect of the black experience was expressed in a song Holiday introduced in 1939. "Strange Fruit" was not about loneliness or disappointment in love, Holiday's usual themes. The song dealt instead with the lynching of black people by whites:

> Southern trees bear a strange fruit,
> Blood on the leaves and blood at the root.
> Black bodies swingin' in the Southern breeze,
> Strange fruit hangin' from the poplar trees.

Despite the song's chilling lyrics, "Strange Fruit" became one of Holiday's most-requested songs.

CARRIED LIKE SCARS

Few African American novelists of the depression era attracted a truly nationwide audience. Then in 1940, Richard Wright published *Native Son*. The son of a Mississippi sharecropper (a tenant farmer), Wright wrote the novel at the same time that he worked for the Federal Writers Project in both Chicago, Illinois, and New York City in the mid-1930s.

The novel's main character is Bigger Thomas, an angry young black man from the Chicago slums. Bigger is tormented by the all-too-obvious differences between the races in his native city. "We black and they white," he bitterly complains to a companion early in the story. "They got things and we ain't. They do things and we can't.... Half the time I feel like I'm on the outside of the world peeping in through a knot-hole in the fence."

At his mother's insistence, Bigger takes a job working for a well-to-do white family. About to be caught with his employer's daughter

in her bedroom, he accidentally smothers the girl while trying to silence her. He quickly disposes of the body. Fearful of the white man's justice, Bigger kills again to keep his crime a secret. Inevitably, he is caught, tried, and sentenced to die. At the end of the novel, Bigger is still struggling to understand his actions and his life as he awaits his execution.

The central message of *Native Son* lies with the danger of failing to deal with racial injustice. Wright risked shocking white readers with his realistic portrait of the sullen, ignorant, and brutal Bigger Thomas. Wright's intention was to show, as he put it, "Bigger's relationship with white America . . . a relationship whose effects are carried by every Negro, like scars, somewhere in his body and mind."

Native Son became both a critical and popular success. The acclaim it brought Wright made him the most respected African American writer in the country.

"ON THE GRIDDLE"

The battle of ideas and dollars had raged around Federal One since its birth. Whenever controversy reared its head, Congress made its displeasure known by cutting funding—and jobs. In the fall of 1936, eight thousand Federal One workers were laid off. More layoffs were planned. "Pink slips and attacks from Congress kept us all in jitters," said one FWP executive. "We were always on the griddle."

Many federal art workers fought back after they were dismissed. In some cases, laid-off artists formed picket lines and staged sit-ins. But not everyone waited to be dismissed before protesting. Some artists joined demonstrations in hopes of staving off the next round of funding cuts. In either case, police were often called in to break up the protests.

Painter James Lechay was one of the scores of artists who picketed to protest being dismissed. "We had to fight the police," he recalled. "Sometimes I ended up in jail." Fortunately for Milton Meltzer, he didn't have to go that far. He and his brother were

among sixteen workers laid off from the Federal Theater Project in late 1936. "We hit the pavement together, joined by a small army of pickets mustered by our union, the Workers Alliance," Meltzer remembered. "For two weeks we kept it up, until that batch [of dismissals] was rescinded, and we were back at our desks."

Most workers who got fired stayed fired. Eleven thousand more arts workers were dismissed in the spring of 1937. The future of the federal arts projects was looking dim.

ROCK-ING THE BOAT

On a June evening in 1937 in New York City, twenty-two-year-old Orson Welles stepped atop a box and signaled for silence. Behind him stood Maxine Elliott's Theatre, padlocked and dark. Waiting on the sidewalk before him was a crowd of several hundred people who had arrived to see the opera *The Cradle Will Rock*. Welles announced that the evening's performance had been relocated. It would take place at the Venice Theater some twenty blocks away.

Welles's announcement was daring, since the Federal Theater Project had officially closed the show. Props, scenery, and costumes were all in federal custody. Worse still, the actors had been forbidden by the Actors Equity union to appear onstage. How could *Rock* possibly go on? Mystified, the crowd followed Welles's lead. On foot or by taxi, bus, or subway, the actors, director, and audience headed uptown for a historic night of theater.

The Cradle Will Rock was a likely target for controversy. Written by Philadelphia composer Marc Blitzstein, *Rock* was a biting satire about corruption in big industry. Its hero was a union organizer named Larry Foreman. In the story, Foreman defies a ruthless steel tycoon called "Mr. Mister" in "Steeltown, U.S.A." In short, *Rock* sent a strongly pro-labor message.

When right-wing members of Congress heard about *Rock*, they quickly surmised that it was pro-communist. Alarmed, they pressured the New York City FTP into slashing the funding for all its theatrical

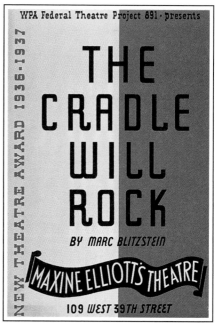

WPA Federal Theatre Project 891·presents

NEW THEATRE AWARD 1936·1937

THE CRADLE WILL ROCK

BY MARC BLITZSTEIN

MAXINE ELLIOTT'S THEATRE

109 WEST 39TH STREET

The Cradle Will Rock *combined operatic arias and modern dance to send a pro-labor message that some found disturbing. Director Orson Welles,* **left,** *moved the show to a new location when the FTP tried to close it.*

productions, including *Rock*. Only days before the scheduled premiere, federal marshals had arrived to lock up Maxine Elliott's.

To composer Blitzstein, director Welles, and producer Houseman, these acts amounted to nothing less than outright censorship. Together with other *Rock* crew members, they entered the theater through an unlocked side door and holed up in the powder room. For two days they plotted strategies for going on with the show. By the afternoon of the would-be premiere, they were still scouring the city for a piano and a theater. By an hour before the opening curtain, they had found both.

At 9:00 P.M., the curtain went up on *The Cradle Will Rock* in the hastily rented Venice Theater. Marc Blitzstein sat alone on a bare stage at a dusty, upright piano. As he began playing the first song, a voice

rang out from the audience. The lighting man swung the spotlight over to pick out actress Olive Stanton singing from among the spectators. Then a young male singer rose from the orchestra to answer her. Again the spotlight swung over. One by one, the actors defying the federal ban stood up in the audience to sing their roles. They were not defying Actors Equity, however; it had said nothing about actors performing offstage.

Rock's extraordinary premiere drew enough attention to win a respectable run. For their insolence, however, Houseman and Welles were banished from the FTP. The defiant men were not down for long, though. They emerged within months to found the Mercury Theater.

The FTP itself did not fare as well. It continued to be caught between rising political opposition and dwindling funds. Headlines about "red artists" (those influenced by communism) brought a reorganization of Federal One in June 1939. The new structure gave the states more control over local projects. The result was that more local groups censored more artists. As for FTP, Congress refused to continue financing it at any level. All its actors were dismissed, and the entire project was shut down.

IN THIS HOUR OF TWILIGHT

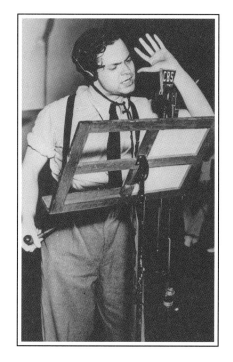

By mid-1938, U.S. citizens were nervously aware that in Europe tensions were growing to crisis proportions. German troops directed by Adolf Hitler had stormed into Austria and stood poised to sweep over the tiny nation of Czechoslovakia. Italy and Japan had both invaded nearby nations. Americans were jittery and dead set against fighting another world war.

With this international drama looming in the background, a voice that crackled over the radio on October 31, 1938, seemed only too real when it announced: "Something's happening." The voice quavered with emotion. "A humped shape is rising out of the pit! I can

make out a small beam of light against a mirror. There's a jet of flame springing from that mirror, and it leaps right at the advancing men. It strikes them head-on!" The Columbia Broadcasting System "newsman" was reporting an astounding event: Martians were invading Earth at Grovers Mill, New Jersey.

When these chilling words came into homes across the country, panic gripped thousands of listeners. In one Newark, New Jersey, neighborhood, families rushed from their homes into the street. Some people covered their mouths with wet handkerchiefs as feeble protection against lethal "Martian gas." A panicked farmer fired his shotgun into a neighbor's water tower, convinced it was a Martian war vehicle. Traffic jams occurred in several cities as worried citizens took to the streets to escape the "Martian heat rays." A teenaged girl later reported, "My two girlfriends and I were crying and holding each other. We felt it was terrible that we should die so young."

About twelve million people heard the broadcast that night. An estimated one million believed that what they heard was fact. What they were actually hearing was fiction, a radio drama called "The War of the Worlds." Its plot was loosely based on a novel by H. G. Wells. The drama was being enacted by Orson Welles and the Mercury Theater of the Air. Welles and colleague Howard Koch had modeled it on a real emergency newscast. Unfortunately, anyone who tuned in late missed the program's introduction. To them, the broadcast sounded like a real-life report of a terrifying war against deadly enemies.

Perhaps more than anything else, this incident introduced Americans to the power of national media. Three years later, their president would use the radio to announce the beginning of a war that was only too real.

THE WORLD OF TOMORROW

In spite of tough times, the depression decade managed to put on the grandest show of all, a world's fair. And it did so not once, but four

"Elektro," a robot made by Westinghouse, blows smoke through his nose at the 1939 New York World's Fair.

times. World's fairs were held in Chicago, Illinois; Dallas, Texas; and San Francisco, California. But perhaps the most memorable fair of the decade opened in 1939: the New York World's Fair.

While world's fairs often celebrated achievements of the past, the New York World's Fair looked to the future—and did so on a giant scale. Dubbed "The World of Tomorrow," it was a $155 million mix of modernistic pavilions contributed by nearly sixty foreign countries and thirty-three U.S. states, sprawled over twelve hundred acres. Dozens of U.S. companies sponsored elaborate exhibits set amid lush gardens, impressive statues, and gushing fountains. Two of the most memorable structures were the Trylon and the Perisphere. The Trylon was a three-sided concrete-and-steel spire that rose seven hundred feet into the air. The Perisphere was the world's largest globe, measuring some two hundred feet in diameter.

Many of the exhibits were remarkable for the time. "Elektro" was a seven-foot robot engineered by Westinghouse. Visitors stared open-mouthed as the 260-pound metallic man walked, talked, and counted on his fingers. People could also experience the launch of a "rocket," float to earth in a parachute-drop ride, or watch graceful "Aquabelles" perform water ballet routines in Billy Rose's Aquacade. But the greatest wonder of all awaited crowds in the RCA pavilion. Here a boxlike metal camera and a seven-inch screen were broadcasting "radio with pictures"—television.

All these exhibits celebrated progress made possible by science. Carl Sagan, who became a noted astronomer, visited the fair when he was a boy. "There, I was offered a vision of a perfect future made possible by science and high technology . . . ," Sagan recalled. "The 'World of Tomorrow' would be sleek, clean, streamlined, and, as far as I could tell, without a trace of poor people."

A 1939 General Electric television set. This TV featured a nine-inch picture tube and twenty-one interior tubes.

The 1939 fair seemed like a glittering, faraway world unto itself. "In this fantastic paradise," praised historian Frederick Lewis Allen, "there were no social classes . . . no hints of grimy days in dreary slums, no Depression worries. Here was a dream of wealth, luxury, and lively beauty."

THE DISTANT FIRE

When the New York World's Fair closed in the summer of 1940, one fair official called it "a tranquilizer for a frightened generation . . . in a world consumed by rage." By that time, the "rage" had spread across most of Europe. Before the Trylon and Perisphere had thrilled their last visitor, the Germans and Italians occupied many neighboring nations, including Ethiopia. France fell in June 1940.

The span of an ocean could not guarantee that the United States would be safe from the strife in Europe. That summer, President Roosevelt asked Congress for twelve billion dollars to begin building the nation's military muscle. He also signed a law to authorize the drafting of young men for military service.

Defense factories and shipyards began humming with activity. Construction jobs skyrocketed as the government built new military bases and military housing. Hundreds of new jobs sprang up each week. By mid-1941, at least two million more people were employed than had been two years before. As the economy lifted, so did people's spirits. One young pilot, John Gillespie Magee Jr., wrote a poem called "High Flight" that vividly expressed the nation's mood: "Oh! I have slipped the surly bonds of Earth/And danced the skies on laughter-silvered wings."

Having waited so long for better times, Americans were enjoying only a brief reprieve, however. As newsman Raymond Clapper reported on the radio, Americans had kept hope during the depression "that if the individual threw in enough struggle and labor he could find his place." Now, as Clapper said, this "hour of mellow twilight" was threatened by "the distant fire rolling toward us."

On December 7, 1941, in a surprise attack, Japanese fighter planes bombed the U.S. Naval Base at Pearl Harbor in Hawaii. More than two thousand American servicemen died. Within hours, President Roosevelt asked Congress to declare war on Japan.

With the nation's entrance into World War II, the Great Depression came at last to an end. Many artists joined the armed forces or took jobs in defense factories. The days of Federal One were numbered as well. The dream of "art for the millions" lasted only until 1943. At that time, Congress terminated all three remaining WPA arts projects. Yet the end of depression-era federal arts programs did not mean the end of government's role in the arts. From the seeds of Federal One bloomed later government arts programs, such as the National Endowment for the Arts.

The accomplishments of this era extend still further. The WPA arts programs did more to bring art to the American people than any other catalyst in American history. Federal One employed only a fraction of the depression's jobless artists, yet its importance to the arts was immense. FAP painter Lillian Orlowsky called its projects "the leading creative adventure of this [the twentieth] century in America."

Whether government-funded or privately sponsored, the arts of the 1930s have left their imprint on a nation's view of itself. Like many others, artists experienced joblessness, poverty, and even hunger. And they survived. Perhaps a little more than others, artists were able to express their experiences for others to share. Partly because of the arts, the lessons of the 1930s have not been lost with time. On canvas, on the page, on stage, and on the nation's walls, the joys and the sorrows of the Great Depression remain—the legacy of a generation of artists who persisted, despite the odds.

DIGGING DEEPER: MOVIES FROM THE DEPRESSION

The movies of the Great Depression in the list below are available in modern libraries and video stores.

THE ADVENTURES OF ROBIN HOOD (WARNER BROTHERS, 1938)

Directed by Michael Curtiz. Errol Flynn portrays the legendary outlaw of Sherwood Forest in twelfth-century England.

ALL QUIET ON THE WESTERN FRONT (UNIVERSAL PICTURES, 1930)

Directed by Lewis Milestone. A group of young German soldiers confront the grim realities of World War I in what may be considered the greatest antiwar film of all time.

DUCK SOUP (UNIVERSAL PICTURES, 1933)

Directed by Leo McCarey. A Marx Brothers classic with Groucho, Chico, Harpo, and Zeppo bringing madcap humor to the imaginary kingdom of Freedonia.

FOOTLIGHT PARADE (WARNER BROTHERS, 1933)

Directed by Lloyd Bacon. James Cagney plays a tough Broadway producer struggling for success. Also starring Dick Powell and Ruby Keeler, this movie includes a spectacular scene, "By a Waterfall," with choreography by Busby Berkeley.

FURY (MGM, 1936)

Directed by Fritz Lang. Spencer Tracy plays a man who escapes a lynching and then seeks revenge on his assailants. Lang also directed the psycho-thriller *M*.

GOLD DIGGERS OF 1933 (WARNER BROTHERS, 1933)

Directed by Mervyn LeRoy. Ginger Rogers and Joan Blondell portray Broadway showgirls trying to survive show business and the depression. The film ends with Busby Berkeley's showstopper "My Forgotten Man."

GONE WITH THE WIND (SELZNICK/MGM, 1939)

Directed by Victor Fleming. This enduring epic of the South during and after the Civil War stars Vivien Leigh as Scarlett O'Hara and Clark Gable as Rhett Butler.

GRAND HOTEL (MGM, 1932)

Directed by Edmund Goulding. Greta Garbo and John Barrymore head a stellar cast playing characters who cross paths in a ritzy hotel. This film won the Academy Award for Best Picture in 1932.

THE GRAPES OF WRATH (TWENTIETH CENTURY-FOX, 1940)

Directed by John Ford. This film version of John Steinbeck's novel dramatizes

the Joad family's flight from the Dust Bowl and their struggle as migrant workers in California. Henry Fonda and Jane Darwell play Tom and Ma Joad.

I AM A FUGITIVE FROM A CHAIN GANG (WARNER BROTHERS, 1932)
Directed by Mervyn LeRoy. Based on the true story of a Georgia convict (played by Paul Muni) condemned to work on a chain gang, this movie examines the cruelty of using chain gangs as criminal punishment.

IT HAPPENED ONE NIGHT (COLUMBIA PICTURES, 1934)
Directed by Frank Capra. Clark Gable plays a reporter who meets a "poor little rich girl" played by Claudette Colbert in this classic romantic comedy.

KING KONG (RKO, 1933)
Directed by Merian C. Cooper and Ernest B. Schoedsack. A fifty-foot gorilla discovered on a prehistoric island becomes enamored of a beautiful woman played by Fay Wray. Tragedy follows when he is shipped off for exhibition in New York.

LITTLE CAESAR (WARNER BROTHERS, 1930)
Directed by Mervyn LeRoy. Edward G. Robinson portrays a Chicago gangster who rises to power only to become a friendless fugitive with a price on his head.

LITTLEST REBEL (TWENTIETH CENTURY-FOX, 1935)
Directed by David Butler. The beloved moppet Shirley Temple plays a little girl who sets out to find her missing soldier father during the Civil War period.

MR. SMITH GOES TO WASHINGTON (COLUMBIA, 1939)
Directed by Frank Capra. Crooked politicians tap the naive young Jefferson Smith (played by James Stewart) to serve out the term of a deceased U.S. senator.

SNOW WHITE AND THE SEVEN DWARFS (WALT DISNEY PRODUCTIONS, 1937)
Directed by David Hand. The world's first full-length cartoon feature, this movie remains a landmark for Disney and the entertainment industry.

STAGECOACH (UNITED ARTIST, 1939)
Directed by John Ford. The first Western produced for general audiences rather than for children, this is the film that made John Wayne a star. Wayne plays a captured outlaw in the Wild West.

THE WIZARD OF OZ (MGM, 1939)
Directed by Victor Fleming. A favorite for generations, this movie stars Judy Garland as a Kansas girl who finds her way home from the land of Oz with the help of the Scarecrow, the Tin Man, the Cowardly Lion, and the mysterious Wizard.

DIGGING DEEPER: BOOKS FROM THE DEPRESSION

Following are just a few of the titles Americans were reading during the 1930s. Many public libraries have copies of these and other depression-era books.

A Farewell to Arms by Ernest Hemingway (1929)

Frederick Henry, an American ambulance driver serving in Italy during World War I, is wounded and falls in love with a beautiful English nurse. This book is considered one of Hemingway's finest novels.

Gone with the Wind by Margaret Mitchell (1936)

The Pulitzer Prize-winning novel about loss and survival during and after the Civil War. The fiery personalities of Mitchell's characters Scarlett O'Hara and Rhett Butler still captivate readers.

The Good Earth by Pearl S. Buck (1931)

This sympathetic novel portrays a struggling peasant family in 1920s China. Winner of the 1932 Pulitzer Prize for fiction.

Grapes of Wrath by John Steinbeck (1938)

Steinbeck's Pulitzer Prize-winning tale follows the Joad family as they lose their farm in Oklahoma and journey westward, hoping to make a new start in California.

Look Homeward, Angel by Thomas Wolfe (1929)

The first novel by one of the South's great writers, this story portrays a North Carolina boy who longs to escape his hometown to become a writer.

Lost Horizon by James Hilton (1933)

The fantastic tale of the kidnapping of a British diplomat who is taken to the mythical Tibetan city of Shangri-la. This book has become a classic.

Of Mice and Men by John Steinbeck (1937)

A fictional tale of innocence and tragedy, this novel follows George and Lennie, two drifters in the Salinas Valley of 1930s California.

Tender Is the Night by F. Scott Fitzgerald (1934)

The French Riviera is the setting for this novel detailing the downward slide of a psychiatrist and his wealthy wife. The plot is believed to mirror Fitzgerald's own deteriorating relationship with his wife, Zelda.

Their Eyes Were Watching God by Zora Neale Hurston (1937)

One of the most influential black authors of the time tells the poignant story of a black woman in the 1930s South who will not be denied her own voice.

DIGGING DEEPER: MURALS OF THE DEPRESSION

Below are the street addresses for a few of the many post offices where depression-era murals can be seen.

ALABAMA
U.S. Post Office
256 Prairie Avenue
Eutaw, AL 35462

ARIZONA
U.S. Post Office
504 South 5th Avenue
Safford, AZ 85546

ARKANSAS
U.S. Post Office
206 North Elm Street
Paris, AR 72855

CALIFORNIA
U.S. Post Office
2000 Allston Way
Berkeley, CA 94704

COLORADO
U.S. Post Office
South Denver Station
225 South Broadway
Denver, CO 80209

CONNECTICUT
U.S. Post Office
120 Middle Street
Bridgeport, CT 06602

DELAWARE
U.S. Post Office
501 Delaware Street
New Castle, DE 19720

FLORIDA
U.S. Post Office
1300 Washington Avenue
Miami Beach, FL 33119

GEORGIA
U.S. Post Office
461 East 2nd Street
Jackson, GA 30233

IDAHO
U.S. Post Office
55 East Oneida Street
Preston, ID 83263

ILLINOIS
Chicago Lakeview Station
1343 West Irving Park Road
Chicago, IL 60613

INDIANA
U.S. Post Office
6255 Carrollton Avenue
Indianapolis, IN 46220

IOWA
U.S. Post Office
525 Kellogg Avenue
Ames, IA 50010

KANSAS
U.S. Post Office
301 North Oak Street
Eureka, KS 67045

KENTUCKY
U.S. Post Office
24 South Fort Thomas Avenue
Fort Thomas, KY 41075

LOUISIANA
U.S. Post Office
1614 Main Street
Jeanerette, LA 70544

MAINE
U.S. Post Office
130 Main Street
Fairfield, ME 04937

MARYLAND
Baltimore—Catonsville Branch
1001 Frederick Road
Baltimore, MD 21228

MASSACHUSETTS
U.S. Post Office
1661 Massachusetts Avenue
Lexington, MA 02420

MICHIGAN
Hamtramck Branch
2933 Caniff Street
Detroit, MI 48212

MINNESOTA
U.S. Post Office
180 Kellogg Boulevard East
Saint Paul, MN 55101

MISSISSIPPI
U.S. Post Office
101 East Main Street
Louisville, MS 39339

MISSOURI
Saint Louis—Main Post Office
1720 Market Street
Saint Louis, MO 63103

MONTANA
U.S. Post Office
2602 1st Avenue North
Billings, MT 59101

NEBRASKA
U.S. Post Office
119 East 11th Street
Schuyler, NE 68661

NEVADA
U.S. Post Office
390 Main Street
Lovelock, NV 89419

NEW HAMPSHIRE
U.S. Post Office
23 Grove Street
Peterborough, NH 03458

NEW JERSEY
U.S. Post Office
1701 Pacific Avenue
Atlantic City, NJ 08401

NEW MEXICO
U.S. Post Office
116 West 1st Street
Portales, NM 88130

NEW YORK
New York—General and Main
 Post Office
421 8th Avenue
James A. Farley Building
New York, NY 10199

NORTH CAROLINA
U.S. Post Office
121 East Main Street
Williamston, NC 27892

NORTH DAKOTA
U.S. Post Office
827 1st Avenue North
New Rockford, ND 58356

OHIO
Cleveland—Pearlbrook Station
4160 Pearl Road
Cleveland, OH 44109

OKLAHOMA
U.S. Post Office
120 East Oak Avenue
Seminole, OK 74868

OREGON
Portland—East Portland Station
1020 SE 7th Avenue
Portland, OR 97214

PENNSYLVANIA
Philadelphia—Spring Garden
 Station
1299 North 7th Street
Philadelphia, PA 19122

PUERTO RICO
U.S. Post Office
60 West McKinley Street
Mayaguez, PR 00680

RHODE ISLAND
U.S. Post Office
17 Grove Avenue
East Providence, RI 02914

SOUTH CAROLINA
U.S. Post Office
129 West Mill Street
Kingstree, SC 29556

SOUTH DAKOTA
U.S. Post Office
100 South 3rd Street
Beresford, SD 57004

TENNESSEE
U.S. Post Office
701 North Main Street
Sweetwater, TN 37874

TEXAS
Fort Worth—Downtown Station
251 West Lancaster Avenue
Forth Worth, TX 76102

UTAH
U.S. Post Office
45 South Main Street, Suite 103
Helper, UT 84526

VERMONT
U.S. Post Office
50 South Main Street
St. Albans, VT 05478

VIRGINIA
U.S. Post Office
3118 Washington Boulevard
Arlington, VA 22210

WASHINGTON
Seattle—University Station
4244 University Way NE
Seattle, WA 98105

WEST VIRGINIA
U.S. Post Office
147 West Main Street
Salem, WV 26426

WISCONSIN
Milwaukee—West Allis Branch
7440 West Greenfield Avenue
West Allis, WI 53214

WYOMING
U.S. Post Office
318 Sapphire Street
Kemmerer, WY 83101

FURTHER READING

Ferris, Jeri. *What I Had Was Singing: The Story of Marian Anderson*. Minneapolis, MN: Carolrhoda Books, Inc., 1994. This award-winning biography for young readers gives a thoughtful account of this distinguished singer's life.

Goldstein, Ernest. *The Journey of Diego Rivera*. Minneapolis, MN: Lerner Publications Company, 1996. A thoughtful text and plenty of full-color reproductions of Rivera's paintings make this book both enjoyable and informative. Includes an account of a controversial mural Rivera planned for New York's Rockefeller Plaza in the 1930s.

Meltzer, Milton. *Violins and Shovels: The WPA Arts Projects*. New York: Delacorte Press, 1976. One of the few books geared for young readers on the New Deal's federal arts programs. Meltzer includes his own experience as a writer employed by the federal arts projects of the 1930s.

Porter, A. P. *Jump at de Sun: The Story of Zora Neale Hurston*. Minneapolis, MN: Carolrhoda Books, Inc., 1992. A well-written biography of this African American novelist.

Stein, Conrad. *The Great Depression*. Chicago: Children's Press, 1989. Though brief, this book touches on many aspects of the 1930s, including popular arts such as movies and songs. Well illustrated with color reproductions of several contemporary paintings.

WEBSITES

<http://memory.loc.gov/ammen/afctshtml/tshome.html> The Library of Congress sponsors this website, where you can hear music from the depression era by clicking on "Audio Titles."

<http://www.nara.gov/exhall/newdeal/newdeal.html> "A New Deal for the Arts." This website is sponsored by the National Archives and Records Administration (NARA). It offers examples of government-sponsored art during the Great Depression and discusses some common themes.

<http://newdeal.feri.org/> "New Deal Network: A Guide to the Great Depression of the 1930s." This website is sponsored by the Franklin and Eleanor Roosevelt Institute and the Institute for Learning Technologies at Teachers College/Columbia University. Among other information, it includes a selection of seventeen slave narratives from the Federal Writers Project.

<http://xroads.virginia.edu> The American Studies Program at the University of Virginia offers excerpts from 1930s radio shows. Click on "The '30s" to find them.

INDEX

ACKNOWLEDGMENTS

Photographs and illustrations used with permission of National Archives, pp. 2–3 (NWDNS-RG-69-3-7340C), 8 (NWDNS-306-NT-157-062C), 10 (NWDNS-306-NT-165-319C), 19 (NWDNS-111-SC-97532), 37 (bottom photo) (NWDNS-RG-69-3-13265-C), 58 (NWDNS-83-G-41563); Library of Congress, pp. 6 (LC-USZ62-17045), 11 (LC-USZ62-30688), 20 (LC-USZC4-7413), 28 (LC-USZC2-813), 30 (LC-USZC2-970), 35 (left photo) (LC-USZC2-1016), 35 (right photo) (LC-USZC2-987), 41 (LC-USZC2-840), 56 (LC-USZ62-11491), 62 (LC-USZ62-5543), 64 (LC-USF33-006093-M4), 65 (LC-USF34-002392-E), 67 (LC-USZ62-95653), 75 (LC-USZ62-90448), 80 (left photo) (LC-USZ62-119765); Wisconsin Center for Film and Theater Research, pp. 12, 51, 53, 54; Smithsonian American Art Museum, Washington, DC/Art Resource, NY, p. 15; © Bettmann/CORBIS, pp. 16, 18, 25, 44, 46, 49; Brown Brothers, p. 22; Hackley Picture Fund, Muskegon Museum of Art, Muskegon, Michigan, p. 24; AXA Financial, Inc, p. 26; Archive Photos, pp. 27, 45, 52, 74; © 2001: Whitney Museum of American Art, New York, p. 33; Franklin D. Roosevelt Library, pp. 34 (NLR-PHOCO-A-7420986), 42 (NLR-PHOCO-A-48491-38), 69 (MO 56-237-11); Federal Art Project, Photographic Division Collection, 1935–1942, Archives of American Art, Smithsonian Institution, pp. 37 (top photo), 57; © Morton Beebe, S.F./ CORBIS, p. 39; The Museum of Modern Art/Film Stills Archive, p. 61; Ohio Historical Society, p. 70; MGM Verve Records, p. 76; Special Collections and Archives, George Mason University Library, p. 80 (right photo); AP/World Wide Photos, pp. 82, 84; © Schenectady Museum, Hall of Electrical History Foundation/CORBIS, p. 85.

Front Cover: Franklin D. Roosevelt Library (MO 90-10)
Back Cover: National Archives (NWDNS-119-CAL-210)
Cover Design by Tim Parlin